HIDDEN HISTORY

of

LITCHFIELD COUNTY

To Larry Peacock,
with Best Wishes!

October 7, 2018

Peter C. Vermilyea

THE
History
PRESS

Published by The History Press
Charleston, SC 29403
www.historypress.net

First published 2014

Manufactured in the United States

ISBN 978.1.62619.577.6

Library of Congress Cataloging-in-Publication Data

Vermilyea, Peter C.
Hidden history of Litchfield County / Peter C. Vermilyea.
pages cm
Includes bibliographical references.
ISBN 978-1-62619-577-6
1. Litchfield County (Conn.)--History. I. Title.
F102.L6V47 2014
974.6'1--dc23
2014035070

For Jill, Ben and Luke

Contents

Acknowledgements

This book is an outgrowth of my blog, hiddeninplainsightblog.com, which has benefited from wonderful conversations with many people. It was inspired by my former history professor at Gettysburg College Michael Birkner. The late Professor Norman Forness was also very influential to me while I was a student. Professor Gabor Boritt remains my mentor and oldest friend in the history business. I am grateful for countless discussions about history with Howard Lewis, Jared Peatman and Dennis Perreault.

None of what follows would have been possible without Cathy Fields, Kate Baldwin Meador, Lee Cook, Liz O'Grady and Jessica Jenkins of the Litchfield Historical Society. Linda Hocking, the society's archivist, provided such indispensible assistance related to the illustrations of this book that she could be listed as a second author.

Also in Litchfield, Audra MacLaren at the Oliver Wolcott Library was not only a great help in digital matters but also worked with Cameron Bove in finding obscure books; Keith Cudworth, James Fischer, Jeff Greenwood and Gerri Griswold of the White Memorial Conservation Center were extremely helpful relating to sites on that institution's property. Lynne Templeton Brickley generously shared her research on African American history. Doug Parker at Litchfield.bz has been a great supporter of this project. Zach Perbeck contributed valuable research assistance. Jim Strub and Mike Main offered excellent advice, and Ed O'Connell has served as my unofficial PR representative.

At Housatonic Valley Regional High School, Mike DeMazza has been both a great encourager and frequent collaborator, and I am tremendously

grateful to Warren Prindle, who lent his artistic and technical expertise to many of this book's illustrations.

I am grateful to the following people for their assistance: John Banks, who provided research guidance and read and commented on the manuscript; Stephen Bartkus of the Gunn Memorial Library and Museum; my former student Emily Bartram of the Hotchkiss Library in Sharon, Connecticut; Jason Bischoff-Wurstle and Katie Piascyk of the New Haven Museum and Historical Society; Katherine Chilcoat, Salisbury town historian; Sierra Dixon of the Connecticut Historical Society; Suzie Fateh of the Mattatuck Museum; Peg Giles of the F.H. DeMars Collection; Mitch Gross of Connecticut Light and Power; Raechel Guest of the Cornwall Historical Society; Judith Kelz of the Glebe House Museum and Gertrude Jekyll Gardens; Lucianne Lavin of the Institute for American Indian Studies; Regina Mason; Marge McAvoy of the Kent Historical Society; Lisa Rousch of the New Milford Historical Society; Jeremy Ruman of the Merwinsville Hotel Restoration; Kim Sheridan of the Connecticut Humanities Council, who provided resources but, more importantly, encouragement; Gloria Thorne of the Sherman Historical Society; and Adam Watson of the Florida State Archives.

It was a pleasure to work with Tabitha Dulla at The History Press, who allowed me great independence while politely keeping tabs on progress.

My father-in-law, Dennis Hovland, has been a great promoter of my work, and my mother-in-law, Sandy, proofread my manuscript. My parents, Pete and Kathy, have always been wonderfully supportive and indulgent of my interest in history, and my sister Megan Lambert put up with it all.

My sons, Ben and Luke, happily accompanied me on treks to sites discussed in this book and helped with research. My wife, Jill, unfailingly supported this project, read drafts of all the chapters and patiently listened to me go on and on about roads from two hundred years ago. They deserve thanks not only for their help on this project but also for making my life so blessed.

Introduction

Let's start with a confession: the history of Litchfield County described in this book is not hidden. The residents of the county have long had an appreciation for the rich history of their hometowns and have adorned their village greens with monuments and markers detailing the past. Vestiges of long-abandoned railroad tracks traverse the county, and remnants of the region's industrial past dot the woods and line the rivers. The history of Litchfield County is tangible for those willing to look for it.

The idea for this book originated in my blog, Hidden in Plain Sight (www. hiddeninplainsightblog.com), the mission of which is to challenge readers to become explorers of their cultural landscapes. This is best encapsulated in the wonderful book *Outside Lies Magic*, in which Harvard professor John Stilgoe writes:

> *Learning to look around sparks curiosity, encourages serendipity. Amazing connections get made that way; questions are raised—and sometimes answered—that would never be otherwise. Any explorer sees things that reward not just a bit of scrutiny but a bit of thought, sometimes a lot of thought over years. Put the things in spatial context or arrange them in time, and they acquire value immediately. Moreover, even the most ordinary of things help make sense of others, even of great historical movement. Noticing dates on cast-iron storm-drain grates and fire hydrants introduces something of the shift of iron-founding from Worcester and Pittsburgh south to Chattanooga and Birmingham. The*

storm-drain grate and the fire hydrant are touchable, direct links with larger concepts, portals into the past of industrialization. Simply put, local history often provides a window from which we can view national events and trends in a more accessible context.

The history of Litchfield County thus parallels the history of the United States at large, and by examining the region's cultural landscape, the explorer gains insights into not only the county's past but the nation's history as well. We find legends involving Native Americans and the county's first white settlers, heroes and common soldiers of the nation's wars, the impact of the industrial and transportation revolutions, religious leaders and reformers, encounters with presidents and even relics of the Cold War.

This book does not use a chronological approach, nor does it offer a town-by-town guide. Rather, it provides a thematic journey through Litchfield County's rich history by exploring the physical reminders of that past that have become hidden in plain sight.

———➤◆◀———

The history of Litchfield County, as is the case for most counties, has been shaped by its geography. It is, therefore, appropriate to begin with an examination of that geography.

It should come as no surprise to those familiar with the county that Litchfield has the lowest population density (206 per square mile) of all of Connecticut's counties. Poor farmland restricted the region's growth in colonial America and determined Native American land usage as well. Receding glaciers scoured the landscape and deposited the innumerable stones that made their way onto the most pronounced feature of the county's cultural landscape, stone walls. Still, the earliest colonists possessed the determination to begin the process of clearing the land and removing the rocks, and as the amount of farmland grew, so, too, did the boundary walls, animal pounds and field fencing.

Equally problematic for the earliest settlers were the Litchfield Hills, as the southern reaches of the Berkshires are known. The mean elevation of the county, 949 feet above sea level, is almost double the 500 feet above sea level mean elevation of the state as a whole. The hills gain in elevation as the traveler moves to the northwest, so whereas the high points of the towns on the county's southern border range from 840 to 1,180 feet, several summits

in the northwest corner top 2,000 feet. Salisbury, in the county's extreme northwest corner, is home to both Mount Frissell, at 2,380 feet the highest point in the county (but shared with Massachusetts), and Bear Mountain, whose 2,323-foot summit lies entirely within Connecticut. The growth of town centers in the county was limited as the hills made water access for concentrated settlements difficult.

The valleys that accompany the hills generally run north–south, creating avenues of transportation that still impact residents today. The major roads of the county—Route 7, Route 8 and the southern portion of Route 202— run north–south, while commuters complain daily about driving the east–west roads that cross the mountains, Route 4 and, especially, Route 44. While the terrain initially inhibited both agriculture and travel, the geological processes that formed the county's topography also pushed iron ore to the surface, providing the means for resourceful settlers to prosper.

Nor was the region blessed with navigable rivers. None of the rivers in the county provides access to the ocean for a seaworthy vessel. While Native Americans and the first European settlers certainly used the local rivers as avenues for paddling, they proved more of a hindrance to east–west travel than an aid to transportation. This is not to suggest that the rivers or other bodies of water in the county did not serve a purpose. Settlers diversified their diets with fish, which the local Native Americans also used as a form of fertilizer. (In the spring, the banks of the Housatonic River are still lined with sportsmen angling for trout.) While not navigable, the streams and rivers of Litchfield County were ideal for powering mills. Gristmills and sawmills peppered the county, and more serious commercial operations appeared along the banks of the Housatonic in New Milford and the Naugatuck River in Torrington and Thomaston.

⸻

The chapters that follow provide a thematic look at the county's history. The focus is on how the events and lifeways of the past have been incorporated into the cultural landscape and thus remain accessible to us, if we are willing to look for them. If the following pages spark curiosity or prompt questions, then this book will have succeeded in fulfilling its goal.

Chapter 1

Legends and Settlement

Waramaug's Rock, sometimes known as the Pinnacle, sits at an elevation of 1,250 feet and offers hikers a breathtaking view of Lake Waramaug, nearly 600 feet below. Those with a keen eye may encounter three large stones organized into a triangle pointing due north. On the stones were once Hebrew inscriptions that have inspired speculation about a lost tribe of Israel settling in what would become the town of Washington.

The best reckoning is that the engravings were of the biblical names Adam, Moses and Isaac and that a particularly erudite resident named Ebeneezer Beeman carved them in the late 1700s. The arrangement of the stones was purportedly done for purposes of triangulation by early cartographers and thus holds no supernatural significance. Waramaug, however, who gave his name to both the precipice and to the lake below, is a figure of historical importance in the history of Litchfield County and is central to another legendary episode of the county's history.

Waramaug was the sachem of the Pootatuck tribe, a subgroup of the Paugussets. The Paugussets were Algonquins, and the sachem was their equivalent of a chief. Waramaug, who first appears in records in 1716, attained notoriety across the tribes of New England, and his "palace," a longhouse reported to be at least twenty feet by one hundred feet and decorated by the finest Native American artists, added to his fame. The palace overlooked the Housatonic at its falls south of present-day New Milford. This, the farthest point north for lamprey eels, was a prime fishing area, and the Pootatucks established their main winter encampments, which

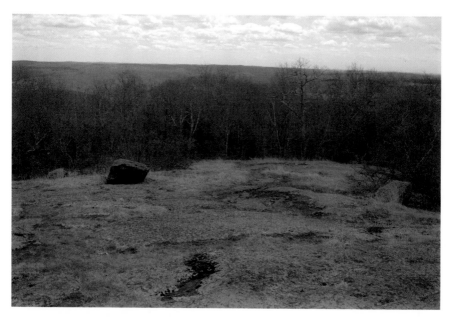

Rocks arrayed in a triangular pattern atop Waramaug's Pinnacle. The Hebrew inscriptions are no longer present. *Photo by author.*

they called Metichawon, here. Summers brought Waramaug and his people to the lake that today bears his name.

The legend, if not familiar, is still predictable. It says that while Waramaug was proud of his status and his palace, his true pride and joy was his daughter, Lillinonah. An exceptionally beautiful and capable young woman, she was courted by braves from far and wide, none of whom could win Waramaug's approval. One wintry day, while walking in the woods alone, Lillinonah came across an English settler. Noticing he was ill, the Pootatuck princess brought him to her village, where she nursed him back to health and fell in love. The sachem at first refused to consent to their marriage, but he was eventually won over, and the Englishman set off for his village to spend one last winter and inform his family of his decision to live with the Pootatucks. Seasons passed, and Lillinonah grew despondent. Convinced her lover would not return, she climbed into a canoe and headed downriver, paddling furiously for the falls. Just before she went over, she saw the Englishman atop the cliffs. She shouted for help; he unhesitatingly dove in; the lovers plummeted to their deaths, wrapped in each other's embrace, at the part of the river in New Milford still known as Lovers' Leap.

There are few reminders of the county's Native American heritage on the cultural landscape. Certainly the names of many rivers, lakes and ponds bear native names. Fort Hill, overlooking Veterans' Bridge across the Housatonic in New Milford, was named for the Indian citadel that stood atop it. It was one of a string of high points used by the Pootatucks as observation points from which an alarm could be sounded. Nineteenth-century historian John W. DeForest wrote that these hills provided the means by which "an alarm could be conveyed down the river, in three hours, over a line of—nobody pretends to tell how many miles."

The threats were real. One of the first recorded interactions between white settlers and Native Americans in the county came in 1676 when Major John Talcott of the Connecticut militia led an expedition into what is now Salisbury in pursuit of followers of King Philip (or Metacomet), the sachem

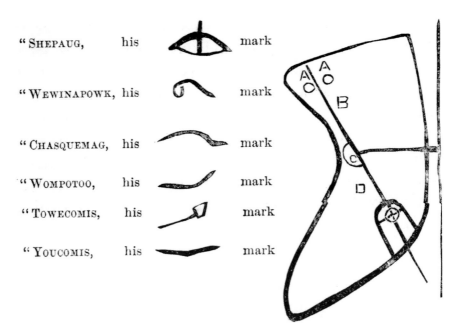

A nineteenth-century map showing the location of historic Native American settlements in New Milford. *From* History of Litchfield County, Connecticut...

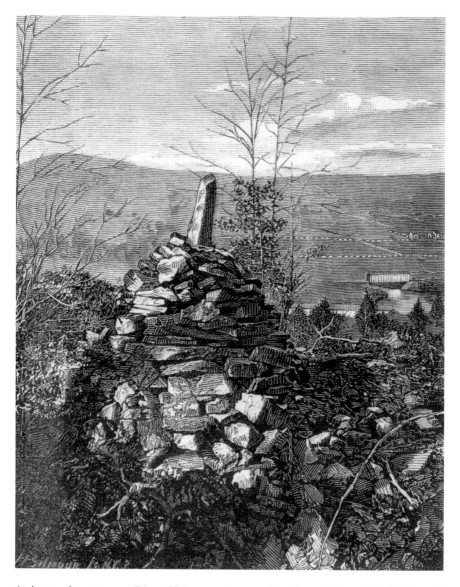

A nineteenth-century rendition of Waramaug's grave. *From Orcutt,* History of the Indians of the Housatonic and Naugatuck.

of the Wampanoag Indians. In a clash fought near the Massachusetts border, forty Native Americans were killed and another fifteen captured.

The coming of European settlers, however, also presented an undetectable danger to Waramaug and his followers: disease. The lack of immunity to

common European diseases led to epidemics that ravaged native populations. Waramaug himself died around 1735; his grave in the Fort Hill area was marked by a large stone cairn that was noted by John Barber in 1838: "I have often seen the grave of this chief in the Indian burying ground, at no great distance from his place of residence; distinguished, however, only by its more ample dimensions, from the surrounding graves, out of many of which large trees are now growing."

According to DeForest, by the time of Waramaug's death, there may have been only one hundred warriors in the New Milford area. These were likely refugees from the southern and eastern portions of the state, pushed out of their traditional lands by European settlement. The Pootatucks would soon be pushed out of southern Litchfield County as well, traveling north to Kent, where they would join with survivors of other tribes—among them Weantinocks and Mohegans—to form the Schaghticoke tribe. By 1774, all native land claims in New Milford were gone, and no Native Americans appeared in the census. Still, Pootatuck fishing rights at the falls of the Housatonic were respected into the nineteenth century.

It was the swamps of Litchfield County that made it appealing to European settlers. Historian Rachel Carley has called Litchfield County the "last, worst acreage in the [Connecticut] colony." The poor, rocky soil made the county ill equipped for any type of agriculture except raising cattle. The challenge posed to colonial farmers was how to feed their cows during the winter months. Swamps provided the answer. By damming the water sources, farmers created meadows, which, in the fall, yielded extremely nutritious feed. Farmers cleared paths and built bridges across the swamps to bring their cattle to feeding grounds in the non-winter months. One of these bridges is still visible, crossing Butternut Brook just west of Route 202, near the entrance to the White Memorial Conservation Center.

These European settlers purchased land claims from the Native Americans of the county. Woodbury was the first town in the county to be settled, in 1673. The men who arrived to scout this area found few Native Americans with whom to do business. New Milford was purchased in 1703, although the natives retained what was known as the Indian Fields, the land on the west side of the Housatonic River opposite the town.

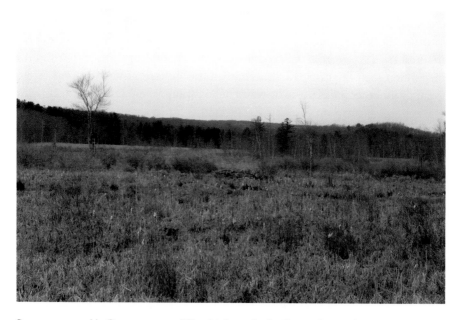

Swampy ground in Bantam; ground like this brought the first settlers to the area. *Photo by author.*

Opposite: A detail of a nineteenth-century rendering of the deed to Litchfield, signed by Native Americans. *Collection of the Litchfield Historical Society, Litchfield, Connecticut.*

Litchfield, amounting to nearly forty-five thousand acres, was purchased for fifteen pounds from the Pootatuck group living at Peantam, today's Bantam. The name *Peantam* derived from the Algonquin for "he prays" because these natives had converted to Christianity. Three men—John Mitchell, Joseph Minor and John Minor—signed for the colonists, along with fourteen native signers. The deed granted the Indians the right to use the land around Mount Tom Pond; in fact, the hill likely draws its name from a colonial nickname for the Native Americans. Here the only recorded native settlement was established, although speculation remains that the Pootatucks also used Bantam Lake, as evidenced by the fact that residents of the area continued to record Native Americans at the lake to fish and sell goods into the nineteenth century.

The Native American presence lasted longer in the northern reaches of the county. Here, Indian refugees fleeing colonial encroachments to the east and west met and, for a short time, found solace in the forests and ponds of what are now Sharon and Salisbury. Significant numbers of Native Americans

and Windsor of the Townships of Litchfield. For aught that appears, it was fairly purchased, and we have no evidence that the natives became dissatisfied with it or expressed any unwillingness to surrender the possession. *[illegible]*

own proper cost and charge, *[illegible]*

And for a more full confirmation hereof, we have set to our hands and seals, this Second day of March, in the second year of his Majesties Reign, Annoq. Dñ. 1715.

Memorandum; before the executing of this instrument, it is understood, that the grantors above named have reserved to themselves a piece of ground sufficient for their hunting houses, near a mountain called Mount Tom.

Signed sealed & delivered in our presence		
Weroamaug B. his mark	Chesqunnoag #	his mark and a seal
Wognaeug his mark	Corkskrew O	his mark and a seal
Tonhocks + his mark	Quinnmp	his mark and a seal
John Mitchell	Magnash +	his mark and a seal
Joseph Minor	Kehow S	his mark and a seal
	Sepunkum C	his mark and a seal
	Pone C	his mark and a seal
	Wonposet	his mark and a seal
	Suckgunnockqueen +	his mark and a seal
	Tawseecume	his mark and a seal
	Mansumpansh L	his mark and a seal

The Indians that subscribed and sealed the aboves'd deed, appeared personally in Woodbury, the day of the date thereof, and acknowledged the said deed to be their free and voluntary act and deed.

Before me

John Minor Justice "

" Entered Nov 5º 1716 "

The above deed is Recorded in Hartford Land Records Vol 8. page 388 or back page 1

19

remained through the middle of the eighteenth century, and there even were fears of Indian raids among the white settlers of towns. The problem stemmed from a dispute about land purchases. While all but 50 acres of Sharon was in possession of European settlers, the natives complained that not all of this land had been legally purchased. A group of forty-five natives asked for a grant of 200 acres, saying they could not survive on the 50 acres. In 1747, the colonial assembly gave the natives 175 acres that belonged to Joseph Skinner, a transaction the local settlers refused to honor. For most of the Native Americans, the solution was to move away, so that by the census of 1752, only two natives—Bartholomew and Neguntemaug—remained in Sharon, and they sold their land to Thomas Barnes of Salisbury later that same year.

Two years later, however, Timotheus, a member of the tribe, returned angry over the failure to obtain a land grant. Declaring, "I vow it is my land…and I will have it," Timotheus began nightly rituals of whooping and throwing stones against houses, along with beating on structures with clubs and hatchets. Neighbors established a guard, and after clashes broke out, the colonial assembly intervened to secure additional money for the natives from those who had purchased their land.

With the exception of the Schaghticoke Reservation, granted by the colonial assembly in 1736 to those native refugees who made their way to Kent, this in effect ended the Native American presence in the county. A 1774 census revealed one Indian in Sharon, nine in Salisbury, sixty-two in Kent, seven in Cornwall, eight in Litchfield and nine in Woodbury.

The settlement of Litchfield County towns generally took two forms. The first was used across the earliest settlements in New England. In this system, at least twenty shares were purchased in a town, the owners forming a corporation. This corporation then determined how the land would be divided. One popular system was to draw "lots," from which the word acquired its usage in real estate circles. The shareholders were usually entitled to between sixty and one hundred acres. The general assembly mandated that land be set aside to build a church, run a school and pay the salary of the minister. The rest of the land was set aside for future use or as common lands—roads, a cemetery and a meetinghouse. Litchfield, for example, was divided into sixty shares. These allotments, however, were smaller than normal, with each

share receiving thirty-nine acres: fifteen around a home lot, a twenty-acre parcel and four acres in the Bantam Swamp. Future divisions would follow.

The size of the towns established under this system varied wildly. Woodbury, for example, was enormous, nearly 150 square miles. The first town to be established in the county, it was settled in 1673 by Samuel Sherman and Lieutenant William Curtiss. Their party was told to make a settlement on the Pomperaug River, 8 miles from its intersection with the Housatonic, but missed their mark and instead followed the Shepaug River through Roxbury to the valley on the east side of Good Hill. Here they found excellent land that presented evidence that Native Americans had cultivated it. Incorporated as a town in 1674, Woodbury would later spin off the Litchfield County towns of Washington, Roxbury and Bethlehem, as well as Southbury and parts of Middlebury and Oxford in New Haven County.

In the second system, speculators purchased land from the Native Americans, had it surveyed and sold it in lots of predetermined sizes. These were often sold to residents of another town in auction. For example, Salisbury and Goshen were sold at auctions in 1737 in Hartford and New Haven, respectively. Canaan was sold at auction in New London in 1738. That same year, Kent and Warren were auctioned off in Windham, and lots in what is now Cornwall were sold in Fairfield.

Those traveling through Litchfield County with a careful eye today may notice discrepancies on signs pertaining to dates of settlement and incorporation. Town settlement in colonial Connecticut was often a four-step process. First, the future towns were purchased and surveyed. Settlers then moved to the site. In the early 1700s, a settlement with twenty families could petition the general assembly for recognition as a town. Finally, when a town possessed enough families to both warrant and afford it, a Congregational church would be established. To complete these steps could take years. Signs in New Milford, for example, say that the town was settled in 1707 (by, among others, Sarah Noble, whose experiences were immortalized in the classic children's story *The Courage of Sarah Noble*) but incorporated in 1712, the same year the residents petitioned the assembly for a church. Litchfield was purchased in 1715 and settled in 1720, and the church was established in 1722.

In Barkhamsted, it was even more dragged out. The land of the town was sold in Windsor in 1732 and was settled by Pelatiah Allyn in 1748; Allyn, however, remained the only resident of the town for ten years! Barkhamsted was not incorporated until 1779 and did not receive a pastor until 1787.

Other towns in the county, especially in its southern reaches, were split off from different towns. For example, Thomaston was once part of Plymouth. Washington and Roxbury, as has already been noted, belonged to Woodbury, and Bridgewater was originally part of New Milford. Morris, known as South Plains, was part of Litchfield.

The names chosen by these early settlers for their towns often reflected either religious or English antecedents. Goshen, Canaan and Sharon fit the former and Litchfield, Kent and Salisbury the latter. Roxbury and Woodbury offer some description of their local geography, while New Hartford and New Milford pay homage to their settlers' points of departure. This is also true of Harwinton, although in an unusual way, as the name reflects its settlement by residents of both Hartford and Windsor.

These towns were responsible for defending themselves against enemies animal and human. At the first town meeting in Canaan, in 1739, a bounty of twelve pence per tail was offered for every rattlesnake killed. Litchfield offered bounties for wolves in addition to rattlesnakes. The town also offered a bounty for the scalp of an enemy Indian.

This was a real fear in the town's earliest days. In 1722, Jacob Griswold of Litchfield was kidnapped by Indians, and his fellow townsman Joseph Harris was shot and scalped. Such actions, and the fears they inspired, resulted in the formation of both militia groups and defensive works. A fort stood on the Litchfield Green, with garrisons radiating out in each of the four cardinal directions. Forts, however, were expensive, and the training required for militia service took men away from their farms. New Hartford, for example, with the county's longest frontier, required many forts, contributing to the slow growth of the town in the colonial period.

The late dates of incorporation for the towns of Litchfield County meant there were few Native Americans for the town militia to guard against. Rather, the militia would be needed to protect the natural rights of the colonists against their mother country, an idea that would have been incomprehensible to those first English settlers who traveled up the rivers of Litchfield County.

Chapter 2

The Revolutionary War Era

The earliest iron furnaces in Litchfield County were built in Salisbury and East Canaan in the late 1730s. By 1750, an iron boom was in full swing, and the hope of fortunes to be made with the plentiful ore lured settlers to the area. It is fitting, then, that the act of Parliament that first called Litchfield County's attention to an assault on their liberties was the Iron Act of 1750. As hardwood forests—which could be turned into charcoal—were a necessity in the production of iron, the denuding of England's forests led to a decrease in the iron produced in the mother country. The Iron Act eliminated taxes on iron exported to Great Britain, thus providing an incentive for American producers.

The law, however, did not stop there, for it also forbade the erection of finishing works such as tilt hammers, steel furnaces or rolling mills. Rather, the county's furnace owners could produce only pig iron (partially refined iron molded into oblong blocks for later use), while English businessmen turned the pigs into the far more valuable finished products. This, seen by some as an assault on economic liberty, may have planted what iron historian Ed Kirby calls the first "seeds of the American Revolution" in Litchfield County.

Those seeds were fertilized by news of the Stamp Act in 1765, which, for the first time, imposed a direct tax on Britain's colonial subjects. News of this

act resulted in the formation of chapters of the Sons of Liberty in Litchfield County. A meeting of the organization took place at the county courthouse in Litchfield in February 1766. Between forty and fifty people were present. Anger over the Stamp Act was expressed, and five agents were selected to represent Litchfield at a larger county convention that was to be held later that month. The meeting, however, was "much hindered" by the presence of opponents of the Patriot movement, who were led by Ebeneezer Marsh.

The official British response to the Boston Tea Party of 1773—in which Dr. Thomas Young, a one-time Sharon resident, played a prominent role—was the Coercive Act, labeled the Intolerable Acts by the Americans. Among these laws was one that closed the port of Boston. Town after town in Litchfield County held emergency meetings to discuss how to respond to Boston's plight. In Litchfield, Oliver Wolcott, a prominent judge and militia leader, crafted a resolution "deeply commiserating" with the "unhappiness of a brave and loyal people, who are thus eminently suffering in a General Cause" and stating that it was Litchfield residents' "indispensible duty to afford their unhappy distressed brethren of said Town of Boston, all reasonable Aid + Support." Norfolk, Salisbury, Sharon and Woodbury took similar action, with the latter actually organizing men to march to the relief of the city.

Canaan's response was perhaps the most immediate and emotional. The July 12, 1774 issue of the *Connecticut Courant* reported:

> *We hear from Canaan, that on the 21ˢᵗ of June last, a large Number of the most respectable Inhabitants of that and neighboring Towns, assembled together, at the Sign of the Brazen Ball and raised a Standard for Liberty, 78 Feet high, and fixed with a Scarlet Flag on the Top, 15 Feet in Length, with the Words* LIBERTY *and* PROPERTY *inscribed on it in large Capitals. After which they retired to Capt. Lawrence's Tavern, where a Number of loyal and constitutional toasts were drank.*

The phrase "Liberty and Property" could be traced to the English Whigs, the political opponents of the King. These men believed that liberty was a natural right and the ownership of private property was the primary bulwark for defending one's liberty. Nearly 250 years later, "Liberty and Property" remains the motto of the town of Canaan.

Canaan's method of protest—known as a liberty pole—was a common form of protest against perceived British oppression. Typically, a red ensign flag was flown from a pole, announcing to observers that they

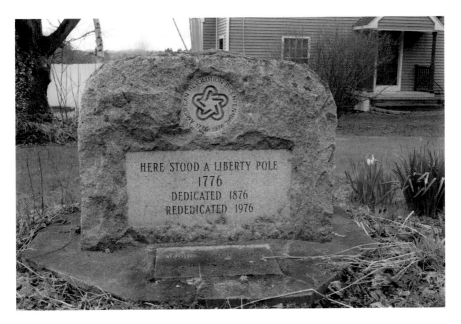

The monument commemorating Goshen's liberty pole along East Street North. *Photo by author.*

should assemble to hear the latest news. Another documented liberty pole stood on what is now East Street North in Goshen, and a small monument marks its location.

With the worsening of relations between England and its colonies, Connecticut towns worked to ready their militia units for potential hostilities. Militia units were as old as the colonies themselves, forming the first line of defense against raids by Native Americans or the French. In 1774, Torrington's militia included 169 men, representing all the townsmen between the ages of twenty and thirty-seven. This was typical of towns in the county. Other local men became prominent in the state militia organization, with Litchfield's Oliver Wolcott appointed a colonel and Sharon's Ebeneezer Gay a lieutenant colonel.

Fears of war turned to reality for Litchfield County residents with news of Lexington and Concord. In Sharon, word of the April 19, 1775 engagements came on Sunday, April 23, when Reverend Cotton Mather Smith announced

the news from the pulpit. Immediately after the congregation was dismissed, the militia organized and paraded, prepared to immediately march to Boston. Twenty-five men from Norfolk headed to Boston upon hearing the news, where they were joined by at least two men from Winchester.

The first experiences of war for most men of the county, however, came with the expedition to Fort Ticonderoga, in the New York colony. Ethan Allen, a familiar figure to county residents, led this expedition. Both Litchfield and Woodbury claim to be Allen's birthplace (a home on Old South Street in Litchfield still bears a marker to this effect), and he was also associated with Cornwall, Salisbury and Sharon. Twenty-eight men from Goshen embarked for Ticonderoga, and men from Cornwall, Harwinton, New Hartford and Torrington also joined the expedition.

Thousands of men from the county served the Patriot cause. An early history of Woodbury identifies 873 soldiers from that town alone, and the *Honor Roll of Litchfield County Revolutionary Soldiers*, published by the Daughters of the American Revolution in 1912, provides 233 pages of names. Among these were at least 16 African American soldiers. Cash Africa of Litchfield was among the first to join following the news of Lexington in April 1775, serving in Connecticut's First Regiment until the ranks were closed to African Americans in 1776. When this policy was abolished, he reenlisted in 1777 and served through the end of the war. Some African American soldiers, among them Jeffery Liberty of Washington, were slaves at the time of their military service and were later emancipated by their owners in recognition of their patriotic zeal.

Still, Litchfield County was not unanimous in its support of the Patriot cause. While eastern Connecticut was widely seen as a hotbed of Patriot sentiment, Loyalists (or Tories) were more common in Connecticut's western counties. One study estimates that 6 percent of the colony's population remained loyal to the Crown, but in a few towns, Tory sentiment approximated that for the Patriots.

Litchfield County's Tories likely remained loyal for religious reasons. Toryism was especially common among Connecticut's Anglicans (Episcopalians), as King George III was recognized as the head of that church. In fact, the Episcopal Church was so widely identified with Toryism that the windows of St. Michael's Church in Litchfield were repeatedly broken until replaced with wood.

The Chippens Hill area of Bristol was notorious as a hotbed for Toryism, and this area included sections of Harwinton and Plymouth. Nineteenth-century historian E.B. Hibbard wrote that pastors at the Plymouth

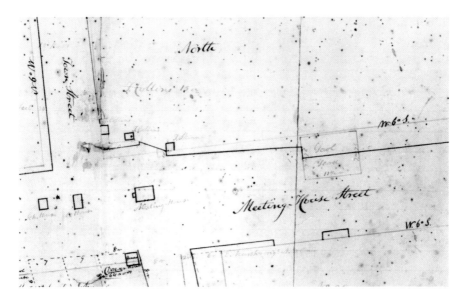

A map showing the location of the jail in Litchfield where William Franklin was housed. *Collection of the Litchfield Historical Society, Litchfield, Connecticut.*

Congregational Church taught their membership that "the colonial cause was treason against government and God." One Plymouth Tory was "hung up till almost dead" on the town green, and another was arrested for high treason, tried and executed in Hartford in March 1777. An area of New Milford is still known as Tory's Cave, and in 1776, a Loyalist from that town was ordered to walk to Litchfield carrying a goose, which was used to tar and feather him.

In 1776, Stephen Hoit of Norfolk raised an entire company of Loyalists for the Prince of Wales American Guard, which attacked Danbury in 1777. After this raid, six Tory families from Danbury moved to Barkhamsted. In their new town, William Wallace Lee has written, "no indignities were too great to be heaped upon them," and their crops were repeatedly destroyed and fences torn down. Lieutenant Benjamin Kilborn of Litchfield and Captains James Landon and Solomon Marsh, both of Salisbury, were reported for Toryism and were removed from their commands. Ultimately, many of the region's Loyalists forfeited their property and made their way to Canada.

The jail in Litchfield (located then on East Street) housed many prominent Tories and British prisoners of war, sometimes twenty or thirty at a time. Among them was William Franklin, Loyalist governor of New Jersey and

son of Benjamin. Franklin described his cell as "a most noisome filthy Room of I believe, the very worst Gaol in America." He continued:

> *In this Dungeon, for I can call it no other, it having often been appropriated to condemn'd Criminals, I was closely confined for about eight Months, overrun and molested with the many kinds of Vermin, debarred of Pen, Ink, and Paper and of all Conversation with every Person, except now and then, a few Words with the Sheriff, Gaoler, or Centries. In short I was in a manner excluded human Society, having little more connexion with Mankind than if I had been buried alive. My Victuals was generally pok'd thro' a Hole in the Door, and my servants but seldom permitted to come into the Room, and then only for a few Minutes in the Presence of the Goaler and the Guard.*

Clearly the £100 the assembly allocated to Sheriff Lynde Lorde to provide for the prisoner was not enough for Franklin to live the quality of life to which he was accustomed.

———◦———

During the Revolutionary War, Connecticut earned the nickname the Provision State for its material support of the Continental army. Litchfield County proudly helped the state earn this appellation.

Connecticut was a major agriculture-producing state at the outbreak of the war, with farmers making their living in corn, beans, peas, squash, onions, apples, tobacco and livestock, especially cattle, horses, sheep and hogs. Livestock was especially important in Litchfield County. Because the county had large pasture areas, its farmers bought lean cattle from New York and fattened them on corn. Drovers from Litchfield and Woodbury then brought cattle and hogs to the Long Island Sound, while those from Sharon brought them to markets on the Hudson River.

These established routes became pathways to supply the army following the outbreak of war. After Lexington and Concord, the Connecticut assembly appointed nine commissaries to purchase supplies for the colony. These were men who had experience either as merchants or in record keeping. In keeping with the importance of the county in provisioning the state, two of them—Oliver Wolcott and Jedediah Strong—were from Litchfield, while Shadrach Osborn of Woodbury was named an assistant commissary.

When New York City fell to the British in 1776, the Patriots lost the ability to transport goods along traditional routes. The reorganization of transportation networks made Woodbury, Litchfield and Sharon essential supply depots. Woodbury historian William Cothren has written that "the streets of the village from the First Congregational church to the soldiers monument were often piled high on either side with barrels and hogshead of pork, beef, lard, flour and other military stores."

Litchfield quartermasters Asabel Baldwin and Oliver Wolcott Jr. presided over a significant operation. A large warehouse of military goods stood at the current intersection of North Street and Norfolk Road, while another, at the site of today's courthouse, allegedly contained cannon captured from Ticonderoga. An army workshop, sixty feet long and two stories high, stood at the foot of East Hill, abutting the East Cemetery. All these depots required military guards.

With Washington's army encamped outside New York City in 1778, Sharon was designated a flour magazine. Supplies from Litchfield and Dutchess County were gathered and stored in the center of town. The amount of provisions in the town worried its residents, and a nearby fire convinced them that the British army was approaching. While this rumor turned out to be false, a local cavalry troop under Captain Dutcher of Salisbury and David Boland of Sharon was kept at hand to protect the stores.

The residents of all the county's towns could boast about the contributions they had made to the Patriot effort. In July 1776, Litchfield County fulfilled a quota of 200 coats, vests and hats and 400 shirts and pairs of shoes. In September 1777, Cornwall provided a total of 100 overalls, hunting shirts, stockings and shoes. Goshen supplied 181 and Harwinton 174. That same year, Litchfield purchased 1,700 pounds of gunpowder, 2,000 pounds of lead, 1,000 flints and 300 pounds of cannon powder. To a request by a local officer from Valley Forge, Norfolk sent 32 pairs of overalls, shoes, mittens and shirts; 59 pairs of stockings; and 2 frock coats. Goshen was home to twenty-eight blacksmiths who made and stored weapons during the war.

For all their contributions, however, no town in the county could match Salisbury's fame when it came to providing for the military. The furnaces of that town produced approximately 75 percent of all American cannon used in the war. Richard Smith, the owner of the Salisbury Furnace, disappeared in 1776 and, when he turned up in England, was suspected of being a Tory. This allowed Connecticut governor Jonathan Trumbull to seize the ironworks in the state's name. The Council of Safety appropriated £100 to refit the works for cannon making and brought in Lemuel Bryant as cannon

maker at the unheard-of rate of two dollars a day plus expenses. Samuel Forbes, the one-time partner of Ethan Allen, came out of retirement to serve as ironmaster. Under his leadership, the Salisbury Furnace set production records during the war. At full strength, more than one hundred men worked at the furnace, and forty guards were employed to protect it from area Tories. All told, nearly 850 cannon were produced in Salisbury in the three years the state ran the furnace. Many of these would serve the Continental and state navies and coastal fortifications. About 150, however, would be transported to the Continental army, where they were used with great effectiveness at the Battles of Trenton, Princeton and Saratoga.

Oliver Wolcott, an old-line New England Puritan, was a conservative who stood opposed to untried political theories, cherished the established political order and has been described by historian Ellsworth Grant as "hardly one to become a staunch advocate of independence." Forty-nine years old in the summer of 1776, Wolcott had been sheriff of Litchfield County and the commissioner of Indian Affairs. In 1775, he was elected to the Continental Congress. On June 28, 1776, in the midst of congressional debates over independence, Wolcott was forced to return to his home in Litchfield because of illness.

On July 1, Wolcott reached New York City, where he decided to spend a few days recuperating at an old friend's house. The city, with a population of twenty thousand at the time, was also populated that month by George Washington's army, transferred there after the British evacuated Boston in March. Further exciting the city was the appearance off the coast of a massive British fleet carrying over thirty thousand men.

Wolcott was still in the city on July 9, when word arrived that the New York State Assembly had approved the Declaration of Independence. In honor of the occasion, Washington ordered that the Declaration be read aloud to the people of the city and the fifteen thousand American soldiers there stationed. The soldiers formed by brigade on the site of the present city hall. From the steps of a nearby row house, Wolcott listened to the results of the deliberations in Congress he had left eleven days earlier.

When Washington's aide finished reading the Declaration, the soldiers were dismissed, maintaining good order with invasion imminent. The crowd, however, had grown restless and searched for ways to expend its collective

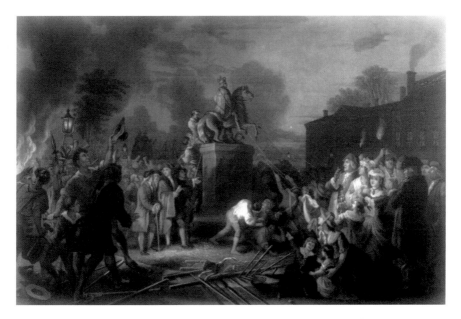

Toppling the statue of King George III at the Bowling Green, New York City, 1776.
Collection of the Litchfield Historical Society, Litchfield, Connecticut.

energy. The mass began to move toward Bowling Green and the Battery, the nerve center of the city in those days. Suddenly, a group of thirty or forty men bearing torches burst into the area. They were Sons of Liberty, and in the midst of a thunderstorm, they lit a massive bonfire and began chanting, "We will be free!"

The rage of the crowd turned against a massive equestrian statue of King George III that had been erected in honor of the king's stance in favor of ending the Stamp Act. Men appeared with ropes, which were tied around the head of the king. As the statue toppled to the ground, Wolcott—converted, apparently, into a radical by the Declaration's rhetoric—appeared in the midst of the crowd, proclaiming, "We can melt it down in Litchfield. We'll need horses and wagons to cart it away." The statue's head was removed and placed on a stake—the traditional British treatment for traitors—outside the American encampment at Fort Washington in upper Manhattan. The rest of the statue was placed on an ox cart and brought, with Wolcott, to the docks, where it was placed on a schooner bound for Norwalk, Connecticut.

The remains of the statue—minus a section that was rescued by Tories in Wilton—arrived in Litchfield before July 18. A shed was erected in an apple orchard adjoining Wolcott's home on South Street in Litchfield. There,

Frederick Wolcott remembered, his father "chopped [the statue] up with the wood axe." Cut into one hundred pieces weighing twenty pounds, the statue was melted in kettles over a fire. The molten lead was poured into bullet molds, resulting in a yield of 21 bullets per pound. While Wolcott dismembered the remnants of the king, his children and a gathering of ladies from Litchfield had, as historian George Woodruff has written, a "frolic in running the bullets and making them into cartridges." Wolcott carefully tallied the results: the statue had been converted into 42,088 cartridges. When the statue was torn down, Ebeneezer Hazard, postmaster of New York City, had correctly predicted that King George's troops "will probably have melted majesty fired at them." Wolcott would command Connecticut militia in the failed defense of New York City before returning to Congress. Once there, he asked to sign the Declaration of Independence, an act that he performed on October 1, 1776.

Wolcott was not the only signer of the Declaration with ties to the county. Upon the death of his father in 1741, Roger Sherman moved to New Milford, where he purchased eighty-seven acres of real estate in the Park Lane section of town. His home there still stands along Route 202. With his brother, he opened a store in 1750 at the site of New Milford's current town hall. The store accepted only Connecticut paper currency, and when debtors offered only New York paper to settle their accounts, Sherman lobbied the state assembly, thereby introducing him to politics. He also began to study law and was admitted to the bar in 1754. He immediately prospered and by the end of 1755 had argued 155 cases before the Fairfield and Litchfield County courts. He served as a town selectman and justice of the peace, as well as a deacon of the Congregational church. When his wife died in 1760, however, Sherman was left with seven children to raise. This led him to move to New Haven, where a law practice required less travel. He prospered there as well, serving as the town's first mayor. He would go on to fame by being the only man to sign the Declaration of Independence, Articles of Confederation, Constitution and Bill of Rights. He also salvaged the Constitutional Convention by proposing the Connecticut (or Great) Compromise, which established the bicameral national legislature.

The signing of the Declaration of Independence would not have happened without the military victories of Ethan Allen and Roxbury's Seth Warner

at Ticonderoga and Crown Point. Warner, a brave and charismatic leader, stood out among his men for his great height. While Allen achieved the surrender of Ticonderoga, Warner oversaw the capture of nearby Crown Point. While dilapidated and severely undermanned, Crown Point still held over one hundred cannon. The best of these were taken to Ticonderoga and ultimately were transported to Boston, where they became the basis for the Continental army's artillery arm. Warner later participated in the campaigns against Montreal and Quebec. (These campaigns featured a large number of men from Litchfield County, and for many years, an elm tree on East Street in Goshen marked the rendezvous point from which twenty-one men from the town embarked for Canada.) Warner was also prominent in the Battles of Hubbardton and Bennington during the 1777 Saratoga Campaign. He died penniless in 1784, and because Connecticut law at the time allowed creditors to seize the body of a dead debtor and sell it to settle the debt, a military guard was ordered to protect Warner's body. Today, his body lies beneath a monument in the center of Roxbury, where Route 67 intersects with Weller's Bridge Road.

The victories at Ticonderoga, Crown Point and Boston were offset by military disaster at New York City. Forced to retreat from the city, General Washington left behind a small garrison at Fort Washington, on the Hudson at the current site of the George Washington Bridge. This was the final Patriot stronghold in the city. Among the defenders was a company of soldiers from Litchfield County commanded by Captain Bezaleel Beebe of Litchfield. These thirty-six men were handpicked to defend the fort and, thus, were trapped inside when the British overwhelmed American defenses on November 1, 1776. Brought to prison ships in New York Harbor, these men were exposed to horrific conditions, denied food and water and exposed to smallpox. When exchanged on December 27, the survivors began their trek home; only five would make it back to Litchfield County alive.

No battles were fought in Litchfield County. However, an engagement in Fairfield County generated great excitement across the county. On April 21, 1777, a British contingent led by Lord Tryon entered Danbury looking to destroy stockpiled provisions. Facing little opposition, the British burned homes, warehouses and farmhouses. Riders carried the news far and wide. Fourteen men from Litchfield—described by historian George Woodruff as the "last capable of bearing arms"—left at midnight. One of them, Salmon Buell, would be wounded in both thighs by a ball. The artillery fire from Danbury could be heard in Goshen, and fifteen men from that town headed to the action. When word reached Sharon, the town bell, recounted

Site of the Continental army's 1778 encampment in New Milford. *Photo by author.*

Opposite: Seth Warner's Roxbury grave. *Photo by author.*

historian Charles Sedgwick, commenced tolling, and it "kept tolling through the night, and it was a night of great terror and solemnity." Woodbury also rushed men to Danbury, and a Woodbury cannon dating to 1624 was used in the action. While not enough Americans arrived to defeat Tryon's force, they did hasten his retreat from the town and prevent further destruction.

Later that year, many of the county's militiamen marched north under the command of Oliver Wolcott in response to the invasion of the Hudson River Valley by John Burgoyne's British force. This resulted in the Battle of Saratoga and the surrender of Burgoyne's army. The following year, Burgoyne's soldiers, now American prisoners, passed through the county en route from Boston to barracks at Charlottesville, Virginia. These men passed through Norfolk, where they camped on the green and one Hessian (a German mercenary fighting for the British) allegedly escaped, married a local woman and settled down. A monument stands along Sand Road in North Canaan commemorating the march of this so-called Convention Army. Another night was spent in Sharon, and the Hessian prisoners encamped in a field opposite the Stone House. Local children long remembered the Hessians singing devotional songs.

Large numbers of Continental soldiers also passed through the county, and some made an encampment in New Milford. From October 25 to November 19, 1778, between two and three thousand soldiers of General Archibald McDougall's division occupied Camp Second Hill at the Benjamin Buckingham farm near where Washington, Roxbury and New Milford meet. While McDougall would complain about being sent "far off the beaten track," Washington had decided to disperse his troops within supporting distance of West Point. McDougall had with him the First and Second Connecticut Brigades and a contingent of Massachusetts soldiers. The camp was never intended to be a permanent winter quarter due to the lack of a consistent supply of food. Rather, the location had been selected in advance because its elevation allowed for excellent observation of British movements while the weather still allowed for campaigning.

Among the soldiers who were encamped here was Private Joseph Plumb Martin, a New Milford resident. In his memoir, Martin recorded leaving a handkerchief behind in a stream after doing laundry. Not knowing that a guard had been sent out to deal with potential deserters, Martin went back to get the cloth. Asked three times to identify himself, Martin failed to recognize that he was the one being spoken to and was fired at by the twelve to fifteen men who composed the guard. Martin recalled that one of the bullets "passed so near my head as to cause my ear to ring for some time after." In the excitement, he fell and banged his knee on a tree stump; this injury continued to plague him in late November, when McDougall's men abandoned Camp Second Hill for the encampment now known as Putman Park in Redding.

⊶◆⊷

Among the most celebrated events in Litchfield County during the Revolutionary War were the three visits of George Washington to the area. On the first of these, Washington traveled from his headquarters north of New York City to Hartford to discuss war plans with the French general Rochambeau. On his way to Hartford on August 23, 1780, the general passed through Litchfield, where he was reportedly entertained at Oliver Wolcott's home. On the return trip, Washington and General Lafayette stopped in the Gaylordsville section of New Milford on September 20 for lunch and a council of war. For centuries, the Washington Oak commemorated this spot; since that tree's death in 2003, a monument has marked the meeting.

The following March, Washington again passed through the county, this time on his way to meet with Rochambeau in Newport to secure naval support for a campaign against New York City. Entering Connecticut on what is now Route 55, Washington traveled north into Kent, where, on March 3, he crossed the Housatonic River at Bulls Bridge. There, an accident occurred, and one of the horses of the party, perhaps the general's, fell into the river. Washington's account books record an expense of $215 for rescuing a horse from the river. Having spent much of the day waiting for the rescue operation, Washington proceeded across portions of New Milford, Washington, Warren, Litchfield and Harwinton before exiting the county.

Washington's final excursion across Litchfield County came in May 1781, when he again met with Rochambeau, this time to plan the Yorktown Campaign. On this trip, Washington is reported to have spent the night at the Sheldon Tavern, which still stands on North Street in Litchfield. The next morning, the general's horse guard was prepared to leave early, but as well-wishers delayed Washington, the troopers paraded up North Street and West Street before departing for Yorktown and ultimate victory in the war.

Chapter 3

Roads

The dearth of adequate roads that made Litchfield County a safe haven for Patriot supplies during the Revolution also limited the county's economic opportunities. For much of the region's early history, Litchfield served as an inland market, where trade goods were gathered for dispersal to points beyond. Other towns in the county—Sharon, for example—functioned as depots for surplus agricultural products that were traded for imported goods. Between the end of the Revolution and 1850, a vast road network was developed in the county to facilitate this trade.

<center>⊷◦⊶</center>

Few aspects of the Litchfield County cultural landscape are as overlooked as its roads. The routes, designs and names of roads provide insight into the county's past.

The oldest roads are those that follow traditional Indian paths. Native Americans had less need for roads, as they did not—until the coming of Europeans—travel by horse or use large wagons or carts. Therefore, the traditional Indian practice of burning underbrush to allow edible plants to grow also served to clear the forests for foot travel. The most popular routes became worn paths. Among these was the Paugusset Path, which connected the Berkshires with the Long Island Sound; we recognize this as Route 7 today.

These paths made travel for the groups of settlers pushing into the northwest hills extraordinarily difficult and slow. Historian G.H. Hollister described such a passage in 1858:

Over mountains, through swamps, across rivers, fording or upon rafts, with the compass to point out their irregular way, slowly they moved westward; now in the open space of the forest, where the sun looked in; now under the shade of the old trees; now struggling through the entanglement of bushes and vines—driving their flocks and herds before them—the strong supporting the weak, the old caring for the young, with hearts cheerful as the month, slowly they moved on.

This was the experience of John Noble and his young daughter Sarah as they journeyed from Westfield, Massachusetts, to what would become New Milford in 1707. Using existing trails, the Nobles moved south along what is now Route 10 to Farmington and then headed east on today's Route 6 through Watertown and Woodbury. Continuing on what would become Route 67, Old Turnpike and Chicken Hill, they forded the Housatonic River at Bennett Street and finally came to Fort Hill and the native inhabitants.

There were two basic types of roads in the colony. Town ways served an intra-town purpose. They could either be private, providing access from a farm to a woodlot, for example, or public, such as an access road to the gristmill. County roads connected a town or settlement with a neighboring community.

In the county's oldest towns—Woodbury, New Milford and Litchfield—these roads were constructed with little regard to future growth. Rather, they were built on an as-needed basis and along axes of convenience. When a new public town way was desired, a request was made to the town meeting, where it was discussed. If approved, a committee was organized to select a route. Farmers were compensated for the loss of their land, and if they objected to the rate of compensation, they could appeal to the county court or the general court of the colony.

Often these towns had one major road, with secondary roads to allow farmers to reach their fields. It was not uncommon for the town to overlook a farmer, who then could appeal to the general assembly to force the town to build a road for him to reach the village center.

In the later-settled towns, those planned by speculators, more thought was put into the layout of the town, and often two long town ways were laid out to provide access for the residents. Additionally, individual lots along these town ways were made larger so that they could encompass fields, pastures and wood lots, thus limiting the need for expensive private roads.

In calling these pathways "roads," the danger arises in comparing them to modern thoroughfares. Rather, the earliest roads in the county were simply cleared swaths. Trees were felled, but stumps and boulders were left in the ground. Teams of four to six oxen would drag a plow across the path of the planned road, while men followed behind to shovel the dirt to the center to attempt to cover most obstacles and to create a crown. More often than not, however, as a road was used more frequently, the center would become lower than the sides. Brooks and creeks often flowed through the road. The width of the road was intended to allow travelers ample room to avoid the obstacles in the road.

The roads of Litchfield illustrate this point. Middle Street, or Gallows Lane, was an amazing twenty-eight rods, or 462 feet, wide. In some places, it is easy for twenty-first-century explorers to see the remnants of these old, significantly wider roads. Along North and South Streets in Litchfield, for example, hitching posts and carriage steps of nineteenth-century inhabitants remain, set considerable distances back from the modern roadways.

If colonial road construction seems less than professional, that is because ordinary townsmen did the work. As early as 1643, well before any town in Litchfield County was founded, the Connecticut General Court mandated that each town appoint two surveyors who would oversee work on roads between towns. An even older law (1638) stipulated that all able-bodied men in town (later defined as men between sixteen and sixty) work for at least one day a year to "keep highways in use." In 1650, the amount of time was increased to two days. Not only was it possible to pay a fine to buy a substitute to do the work in one's place, but the potential fines were so small as to encourage men to neglect their duties.

The earliest major thoroughfares in the county ran westward to the Hudson River, enabling agricultural products and iron to reach markets. Iron ore was brought off Salisbury's Mount Riga in saddlebags and on oxcarts. The frequency with which ore-filled carts traveled through Kent quickly wore down the town's roads. In some instances, towns attempted to utilize corduroy roads in which logs were used as a base across wet ground and then covered with sand or dirt. Despite these attempts at improvement, the maintenance of roads was a never-ending task for colonial towns.

Clamshell Drive at Watering Trough. This image gives a sense of the conditions of early roads. *Collection of the Gunn Memorial Library and Museum, Washington, Connecticut.*

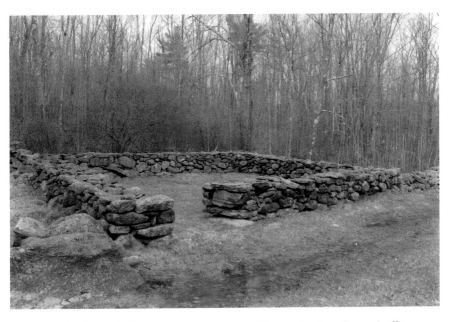

Goshen's animal pound. These were once common sights used to keep livestock off town roads. *Photo by author.*

The difficulty of maintaining roads set among the stones, frost heaves and unpredictable weather of northwestern Connecticut earned these thoroughfares a reputation as the worst in the colonies. Dr. Samuel Holten, who traveled from Boston to Philadelphia in June 1778, wrote that the roads from Hartford to Litchfield were "very bad" but that those from Litchfield to the New York line were the "worst he ever saw."

Even on the very best roads in good weather, a typical traveler could make between ten and fifteen miles a day, while an excellent rider could make between eighteen and twenty miles a day. However, in most cases, travelers walked alongside their team, and riding horses was a luxury enjoyed only by the wealthy. It was not uncommon to see either two or three (husband, wife and child) riders on a single horse. Travelers had to share the roads with livestock, which was an inconvenience even when tended. And animals, of course, had to be watered, which would also slow down travel, assuming a water stop could be found. In the eighteenth century, the Catlin family of Harwinton used a spring-fed trough to establish an early rest stop. The Catlin Trough monument stands on Bentley Drive in Harwinton as a reminder of this period in our transportation history.

Untended livestock was so potentially disruptive, even dangerous, that pounds were built to house them. Animal wardens were paid by the town to bring the animals to the pounds, and the owners had to pay a fine upon collecting their livestock. An excellent example of one such pound still stands on East Street North in Goshen.

The task of building roads continued, however, urged on by the hope of colonists to escape the isolation that accompanied life in eighteenth-century Litchfield County. Within twenty years of its founding, Litchfield's residents had opened roads to New Milford, Goshen, Woodbury and Harwinton, and the Litchfield Toll Gate would soon become a popular stop for travelers on the Hartford-Litchfield-Albany axis.

At Cornwall's first town meeting in 1738, residents voted to lay out highways to Kent and Litchfield, going so far as to specify that the road be at least six rods wide. What is now Highland Avenue was Torrington's first publicly built road and thus part of an attempt to overcome a disconnect between the eastern and western sides of town. A large swamp between the two sections prevented communication; a rider trying to bring news of

a town meeting from the western side of town to the eastern would need to travel far to the north to evade the swamp, cross the Naugatuck River twice and ascend the hills on the eastern side of town.

This disconnect was a well-known feeling to county residents. Historian Isabel Mitchell recounted one wag's take on Cornwall's isolation from the outside world: "Yes, go to Cornwall and you will have no need of a jail, for whoever gets in can never get out again."

Beyond the rugged geography of the region, the cost of roads precluded their construction. A road to run from New Hartford to Barkhamsted was approved by the former town only "if they can do it without pooting the town of New Hartford to but little caust [*sic*]." Securing the land was an additional expense; in 1754, Torrington paid Aaron Loomis twenty-two pounds ten shillings for one acre of land needed to complete a road, and five years later, Samuel Dorwin was given an exchange of land and two pounds so that access roads to neighboring farms could be built.

Bridges were even more expensive than roads. Towns were responsible for the cost of bridges in addition to roads. Torrington residents objected to a five-cent-per-$1,000 tax to build a bridge over the Naugatuck River to allow a road to pass to West Simsbury. Since this was not an uncommon objection, to fund bridges, towns sought permission to hold lotteries, bartered land for labor, granted the right to build tolls in exchange for building a bridge (an arrangement that would come back to haunt the towns that gave the right to charge a toll in perpetuity; those rights had to be purchased at high cost) or formed joint-stock companies. By the early nineteenth century, half of all joint-stock companies in Connecticut were formed to build roads or bridges.

A typical bridge would last seven to ten years. To increase the lifespan, bridges were covered. Burrall's Bridge, which stood very close to where the Amesville Bridge between Salisbury and Falls Village is today, was the first bridge in that area to cross the Housatonic. Its toll had to be increased substantially because the weight of the iron being brought across the bridge accelerated the need for repairs.

Both the West Cornwall covered bridge and the Bulls Bridge, which still stand, were typical bridges of the period. The West Cornwall bridge uses native oak beams to span the river—128 feet—from stone abutments on either side. Queen Rod trusses add support. Kent's Bulls Bridge was built to facilitate the movement of iron ore to armories for the Revolutionary War. It provided a more direct route from Newburgh to Hartford. Ithiel Town, a noted New Haven architect, supervised later versions of both bridges. It is interesting to note that the floods of 1955 washed away two

Coming Through Bulls Bridge. Collection of the Kent Historical Society, Kent, Connecticut.

steel and concrete bridges in the area, but these covered bridges remained. (Steel beams and central piers were added to Bulls Bridge in 1969 and to the Cornwall covered bridge in 1973 to strengthen the spans.)

New forms of travel—in the latter part of the eighteenth century, the stagecoach—altered the region's transportation infrastructure. The earliest stage service in the county dated to 1760. While stages certainly offered more comfort than walking, they were not luxurious modes of travel. Stagecoaches had no shocks and could make only four to five miles per hour. Typically, four horses pulled a stage, and those horses needed to be changed about every ten miles.

Still, the stage became a vital part of Litchfield's rise to being one of the nation's leading centers of education at the dawn of the eighteenth century. Students bound for either the Litchfield Law School or the Litchfield Female Academy arrived in town via stage, not horseback.

Stagecoaches often left before dawn. Drivers hoped to make ten miles before breakfast, which would be served at the first stop to change horses. The

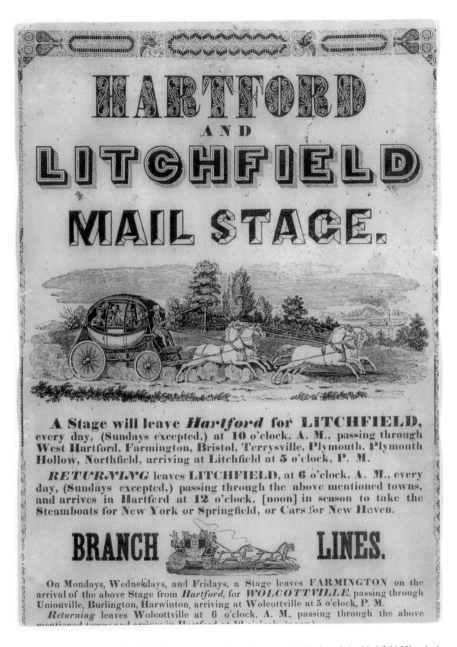

A nineteenth-century Litchfield stagecoach advertisement. *Collection of the Litchfield Historical Society, Litchfield, Connecticut.*

stage from Litchfield to Norwalk left at 3:00 a.m. (despite an advertisement promising "no night travel") and traveled to New Milford and Danbury, where travelers would spend the night before continuing to Norwalk and a ship to New York City in the morning.

The Knickberbocker Tavern in Canaan was an overnight stop on the stage line between Hartford and Albany. Before reaching the tavern, however, travelers would have to brave the wilds of Barkhamsted in the creeping darkness. Ellsworth Grant recounted that the Chaughan cabin became known as the Barkhamsted Lighthouse, as drivers—upon seeing the fires in the cabin's kitchen—would yell out, "There's Barkhamsted Lighthouse, only five more miles to New Hartford."

Travel times on stagecoaches were a direct result of the road conditions. The thirty miles from Litchfield to Hartford would take a stage approximately nine hours; the forty miles to New Haven would take a proportionate twelve hours. The poor roads through Cornwall and Sharon, however, meant that a stage from Litchfield to the latter town would take fourteen hours to travel twenty-four miles. The last stagecoach to Litchfield ran in 1870, having been made obsolete by the railroad.

* * *

Independence from the British meant that trade had to be carried out exclusively by Americans. To accomplish this, a new system of roadways was needed to bring goods from the ports to the inland markets and then on to the agricultural towns. Complicating this was the fact that the end of the Revolution brought an end to statute labor laws, as taxes were used to hire workers with greater expertise. However, the enormous debt faced by the new State of Connecticut ($1.6 million in 1783) and the wariness of Americans to be taxed by their government in the wake of the Revolution led them to look to private solutions to the transportation problem.

The answer was privately chartered turnpikes. Between 1795 and 1853, 121 turnpikes were chartered in the state. Corporations, formed for the express purpose of building a roadway, would apply to the state for a charter. If the state agreed with the need for such a road, it would grant its approval, oversee the drafting of a route and instruct the impacted towns to purchase the needed land.

The turnpike company constructed the road and any larger bridges (local towns had to pay for the smaller ones). In exchange, the company was given

the right to operate two tolls per road and collect up to a 12 percent annual return on its investment. As a defense against price gouging, if a turnpike company collected more, the road would revert to public control.

A typical turnpike was constructed by a team of workers equipped with hoes, shovels and picks. These tools were likely locally made, as the Industrial Revolution was in its infancy. They were complemented by ox-drawn carts and wagons to remove dirt and a "one-horse shoe," a metal disc that when pulled by oxen could scrape away rocks and dig drainage channels. Typically, such turnpikes were twenty to twenty-four feet wide, with reduced grades at hills.

The companies—or even some individuals—often placed mile markers alongside the road. Two mile markers remain in Litchfield. Jedediah Strong erected one in 1787 in front of what is now Litchfield Bancorp along 202 in Litchfield. It still informs travelers that it is 33 miles to Hartford and 102 miles to New York City. A second mile marker stands on Norfolk Road in Litchfield. A mile marker allegedly placed by Benjamin Franklin remains on Main Street in Woodbury. Additionally, a replica mile marker from the Albany Turnpike stands at the head of the New Milford green, noting that it is 85 miles to Albany and 36 miles to New Haven.

Signposts were often erected at the junction of two turnpikes. The Harwinton signpost (a similar one stands in front of the Milton Hall) is an excellent example of these traffic control devices, which sought to reassure travelers that they were taking the correct route.

In the 1790s, it was fashionable to construct turnpikes according to the French style, which called for long, wide roads with as few turns as possible. These roads consequently encountered more steep grades and water crossings. The Straits Turnpike between Morris and Litchfield and its northern continuation from Litchfield to Goshen and then Canaan (today's Route 63) is a good example of such a road. Sometimes, however, these roads were found to be impractical, as was the case with the Litchfield/New Milford Turnpike that originally passed over the top of Mount Tom in Bantam.

Tollgates were built at locations where it was difficult for travelers to avoid them. For example, one of the tollgates on the Goshen/Sharon Turnpike was located at the bridge in West Cornwall; the other was located at Tyler Lake. It was a common thought among nineteenth-century travelers that it was almost impossible to get into or out of Litchfield without paying a toll. Still, travelers tried, and an increasing number of "shunpikes," or roads that passed around tollgates, appeared in the county.

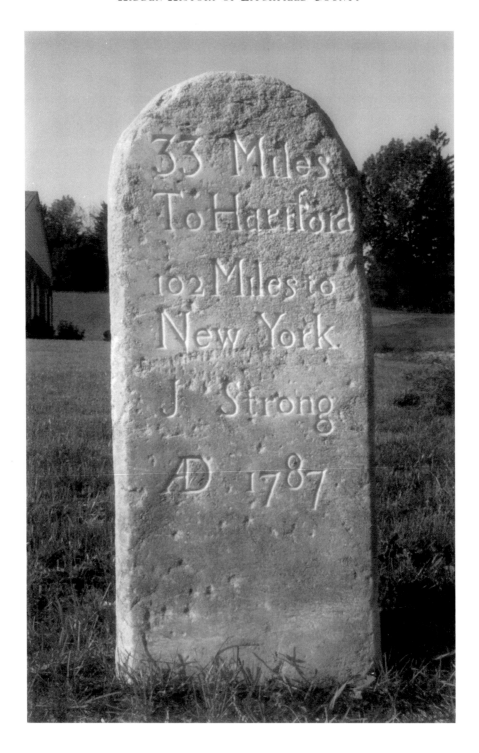

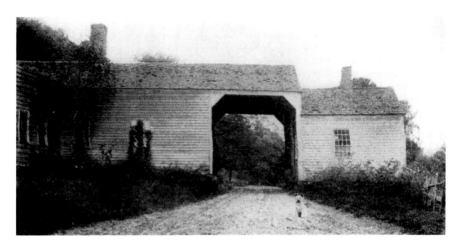

An early twentieth-century photograph of a tollhouse in Norfolk. *From Wood,* The Turnpikes of New England...

Opposite: Jedediah Strong's mile marker along what is now Route 202 in Litchfield. *Collection of the Litchfield Historical Society, Litchfield, Connecticut.*

The Greenwoods Turnpike, which ran from New Hartford to Winsted to Norfolk before continuing on to the Massachusetts border, was one of the most successful turnpikes in state history. It was built between 1798 and 1799 at a cost of $19,500, or $815 per mile. The roadway paid dividends for seventy years and was so successful that its overseers reinvested profits into maintenance so that they didn't exceed the 12 percent profit cap. This, however, was an exception, as over 80 percent of Connecticut's turnpikes operated with little to no return on investment. The turnpike that continued from the Greenwoods Turnpike at the Massachusetts border on to Suffield was a more typical example; that road lasted only four years before going bankrupt.

The appearance of an increasing number of shunpikes and the emergence of the railroad as an alternative to turnpikes led to the end of the era of turnpikes. When turnpikes were no longer economically viable, they reverted to public control. This was done with increasing frequency after 1850, and Connecticut's last private tollage was removed in 1897.

Chapter 4

Religion

There were no presidents born in Litchfield County nor any famous battles fought within its borders. The county, however, has left an indelible mark on the nation's religious history.

———◆◆◆———

Those early settlers who relocated to Litchfield County from Hartford and Windsor brought with them their livestock, belongings and fervent Congregationalism. They were descendants of the Puritans who fled the Church of England in the 1630s in order to practice freely in Massachusetts Bay. In transplanting to Connecticut, they established the Congregational Church—the formalized institution of Puritanism—as the official religion of the Connecticut colony. Some degree of establishment of the Congregational Church as the official religion of Connecticut lasted until 1818, nearly thirty years after the adoption of the First Amendment and its guarantee of religious freedom.

The Reverend Daniel Boardman, a 1709 graduate of Yale University, was brought to New Milford in 1713 and given land and a house in exchange for being the town's first Congregational minister. Boardman immediately became active in attempting to convert the Native Americans of the town and became particularly close to Chief Waramaug. Whether Waramaug converted to Christianity remains a matter of speculation; however, when

he was on his deathbed, the chief called for Boardman to come to his side and pray for him. Waramaug's wife, skeptical of the clergyman's powers, summoned the tribal medicine man, and for the next three hours, a contest ensued between the two religious leaders over who could pray the loudest. According to legend, the medicine man gave a final shout, fled the scene and dove into the Housatonic River.

———◦◦◦———

The organization of the Congregational Church in Litchfield is representative of the history of the church in the county. The Congregational church building in most New England towns was known as the meetinghouse because it functioned as the site of the town's secular as well as sacred business. Litchfield's first meetinghouse was laid out on Meeting House Street, today's North and South Streets. It was located on what is now the center green.

The center of the town was marked not by the green as it appears today but by roads so wide that they were essentially vast open spaces. West Street was 264 feet wide and East Street over 300 feet wide. The church stood in the middle of this square. The building itself was 45 feet long and 25 feet wide with clapboarded sides and a shingled roof. It did not have a steeple.

Building a church was a community effort. When the Congregational church was built in Barkhamsted, volunteers from Granby, Simsbury and New Hartford arrived to help with the construction. A church building was not a necessity for services—Bethlehem held services in Joseph Bellamy's barn for four years—but was a mark of pride for the town.

More important than the building for a fledgling town was the hiring of a minister. Of the vital role the minister played in the life of the colonial town, Arthur Goodenough, an early student of Litchfield County's religious history, wrote, "He ruled the old men, being at once their counselor and boon companion. The young men were his children."

The minister, usually a graduate of Yale but sometimes of Harvard, was also the leading proponent of education in the community. His personal library was often the sole source of books for the town, and ministers played an important role in the founding of early public libraries in New England. Norfolk, which had a population of 969 in 1774, sent 113 young men to college under the tutelage of Pastor Ammi Ruhamah Robbins.

Litchfield's meetinghouse, drawn by Mary Ann Lewis, circa 1780. *Collection of the Litchfield Historical Society, Litchfield, Connecticut.*

Opposite: An extract from a sermon by Joseph Bellamy. *Collection of the Litchfield Historical Society, Litchfield, Connecticut.*

Part of Sermon By Jos. Bellamy D.D.

Great Articles of the Christian Religion, affords unto Chri...
a Great deal of Support & Comft. While ceither ⊙. By y̓ Gos...
We have a Clearer Discovery of Life & immortality yn was ever be-
fore made unto y̓ ⊙. And hence it is y̓ Christ is Said to have brot...
y̓ Immortality to light by y̓ Gospel. y̓ Gospel teaches us more plain-
ly y̓ y̓ Law of Moses did Abt y̓ future rewards of y̓ righteous & God-
ly. And y̓ future Punishmts of y̓ Wicked & Ungodly: It Declares t...
as y̓ it Shall Certainly y̓ow well with y̓ righteous in y̓ Great Day of
Judgmt but y̓ it Shall be ill with y̓ Wicked, there Shall be Everlas-
ingly Miserable, & there Shall be Everlastingly happy. And so y̓ Gospel
teaches us y̓ Christ Who was y̓ Son of y̓, & partook of the Divine Natur
Came into y̓ World to Save Sinners & y̓ he lived here a holy life, Went
a bout doing Good, healed infirmities, Cured Sicknesses & Diseases, And
... the ... bodies of Men So he did ... Soul, Continually y̓
... y̓ unto a holy religious life to faith in him & Obedience to him
And Encourag̓ y̓m to Come into his Service & take upon y̓ his
yoke which was Easy & his burden & heavious light, & he long g̓...
...y̓ were Obstinate & Rebellious & wod n̓t hear his Voice. And it
... us y̓ after he had thus Spent his life y̓ he Was barbarously
Crucifyd by y̓ Jews Was dead & buried & rose again on y̓ 3 Day;
And after he was Seen & known of his disciples, & Contin̓ued on Earth
for 40 daies he in y̓ Sight of a Great Multitude Ascended up into
heaven And there Sits at y̓ right hand of y̓ Majesty on high; It
teaches us Also y̓ Christ Comissn̓ his Apostles to Go forth y̓
preach y̓ Gospel of his Kingdom to All Nations & to Offer Salvat...
in his Name to Every Creature, And y̓ he is So & to indure...
... y̓ he is, & freely... soever Comes to him towar...
... And As y̓ Gospel teaches us they bid y̓ f...

Given to Rev. Jno. Hutchins by Mrs. Child

Litchfield's first minister was the Reverend Timothy Collins. Collins, born in Guilford in 1699, was a 1718 graduate of Yale. Installed as Litchfield's minister on June 19, 1723, following negotiations over his house and land, his annual salary was set at fifty-seven pounds with scheduled raises until it reached eighty pounds. Collins's tenure was a tumultuous one. While he remained as minister in Litchfield for nearly thirty years, there were repeated attempts to oust him from the pulpit. Although these disagreements were publicly about money, a motivating theological factor behind them was Collins's resistance to the ideas of the Great Awakening.

The Great Awakening, which swept the American colonies in the 1740s, arose in response to the increasingly pedantic tone of Congregational ministers and the increasingly structured and formal organization of the churches. Instead, those ministers involved with the Great Awakening (who became known as New Lights as opposed to the Old Lights, who favored traditional ways) looked to shift the emphasis of their congregants to a religion based on spirituality. Among the best known of the New Lights were Jonathan Edwards and George Whitefield. Whitefield preached in Sharon in 1770, an occasion commemorated with a marker that still stands on the Sharon Green.

Collins was an ardent Old Light, and while most of Litchfield County rejected the revivalism of the Great Awakening, one of the most powerful forces for New Light theology was Joseph Bellamy of Bethlehem. Known as the "Pope of Litchfield County," Bellamy was born in Cheshire in 1719, graduated from Yale, spent a year studying under Edwards and in 1740 was installed in Bethlehem.

While Bellamy held fast to many traditional Puritan beliefs, he believed that God promised all people salvation, not just a select few. Unlike Edwards and Whitefield, whose power stemmed from their abilities to move audiences, Bellamy's influence rested with his intellectual capacity to shape the minds of other ministers. Most important in achieving this were his 1750 book, *True Religion Delineated*, and his mentoring of aspiring preachers. His house still stands in the center of Bethlehem (operated as a historic home museum, the Bellamy-Ferriday House), and a monument to him stands on the town green.

Bellamy's charisma did appeal to a number of the Litchfield congregation who turned away from Collins and his Old Light message and traveled to Bethlehem. The Litchfield church was forced to appeal to the general court of Connecticut to demand that these New Lights return to the Litchfield

church. This dispute led the churchgoers of the South Farms area of town to petition the general assembly to be a town in their own right. Eventually, this area became Morris.

———————•◦•———————

The importance and lengths of religious services are evident in the construction of Sabbath day (or sabbaday) houses in the common area around the meetinghouse. These were commonplace across the county, with references to them being found in the town histories of Barkhamsted, Litchfield and New Milford. Those families who lived at a considerable distance from the meetinghouse built these sabbaday houses. As Congregational services consisted of forenoon and afternoon sessions, these families were unable to return home for a meal during the recess. Instead, two families would work together to build a two-room, twelve- by twelve-foot structure with a chimney and two fireplaces.

On Sunday mornings, they would fill their saddlebags with food and either beer or cider and head to their sabbaday house. There they would drop off the food and stoke the stove, since Congregational churches were not heated. During the noontime recess, the families would retire to their sabbaday houses, where they would have their meal and listen to the father review the scripture and sermon before returning to the meetinghouse for the afternoon session.

———————•◦•———————

The Unity of Brethren, better known as the Moravians, also played an important role in the early religious history of the county. The group's nickname stems from the refugees from Moravia, an area of the present-day Czech Republic. The Moravians were essentially followers of the Catholic revolutionary Jan Hus, who advocated for giving lay people a more prominent role in the church and having Masses said in vernacular languages. Hus was burned at the stake in 1415.

One of the principal tenets of the Moravian Church is the "ideal of service," which emphasizes the importance of educational and missionary work. At the forefront of these ideals was Count Nicolaus von Zinzendorf, a German social reformer and Moravian bishop who led efforts to spread Christianity through

A mid-nineteenth-century artist's rendering of the Moravian monument in Sharon. *From Orcutt,* History of the Indians of the Housatonic and Naugatuck.

the Native Americans of the Northeast. Around 1740, von Zinzendorf himself came to America and preached to Indians in New Milford. He was so successful in igniting the fire of Moravianism that the natives agreed to move with Zinzendorf to Bethlem (today Bethlehem), Pennsylvania.

Around the same time, a second Moravian mission was established in Sharon to minister to the settlements at Shekomeko (Pine Plains, New York), Wequagnock (near Sharon) and the Schaghticokes in Kent. The mission was founded by the Reverend Christian Henry Rauch, who presided for two years before turning the work over to twenty-six-year-old Reverend Gotlieb Buetner, who died two years later and was buried at the site of the mission.

New York State chased the Moravians out of its borders in 1745, fearing that the missionaries were secret emissaries of the Catholic Church. This led numerous Christian Indians to settle around Sharon, where the Moravian mission continued under the leadership of David Bruce, a Moravian teacher from Edinburgh, Scotland. In 1789, George Loskiel wrote of Bruce's activities in his *History of the Moravian Missioners Among the North American Indians*:

> *Bruce…resided chiefly in a house at Wequagnock…but sometimes resided at Schaticook, whence he paid visits to Westenhunk, by invitation of the*

head chief of the Mohikan nation, soweing the seeds of the gospel wherever he came…Twenty Indians were added to the church by baptism. Brother Bruce remained in his station till his happy departure out of time…He was remarkably cheerful during his illness, and his conversation edified all who saw him. Perceiving that his end approached, he called his Indian brethren present to his bedside, and, pressing their hands to his breast, besought them fervently to remain faithful unto the end, and immediately fell asleep in the Lord.

That was July 9, 1749. A monument to Bruce and Joseph Powel, a later Moravian missionary, was erected in Sharon in October 1859, 110 years after Bruce's death. The monument still stands, hidden deep within the woods along Route 361. On its east face is the following passage from Isaiah:

How beautiful upon the mountains
Are the feet of him that bringeth
Good tidings, that publisheth peace,
That bringeth good tidings of good,
That publisheth salvation.

———◆———

If the Moravians played a vital role in the history of Litchfield County, then the county played a foundational role in the history of the Episcopal Church. The American Episcopal Church would emerge, in the era of the Revolutionary War, from the Church of England (also known as the Anglican Church).

The growth of the Anglican Church was stymied by the fact that townspeople already had to pay a tax to support the established Congregational Church. Those who wished to practice as Anglicans had to pay a separate fee to support the Anglican Church and pay the minister. This toleration, however, did not mean that the state welcomed dissension. Stephen Lee, an Anglican from Cornwall, learned this the hard way. In 1750, Lee, "being firmly attached to the Church, refused paying the collector for the support of the dissenting minister of the place, and for this, was committed to the gaol in Hartford." The Reverend William Gibbs, Anglican minister of Simsbury and occasionally of Cornwall, visited Lee in the prison and "took pity on him"; Gibbs paid twenty-one pounds to free Lee and settle his back taxes. Still, new groups of Anglicans continued to organize.

John Davies arrived in Litchfield from England in 1745 and found a town divided by the disturbances that stemmed from the Great Awakening. In November of that year, Davies organized a meeting of thirteen families at the home of Jacob Griswold a mile west of the village; here, Litchfield's Anglican (or Episcopal) church was established. (Many of these new Anglicans were Congregationalists upset with Reverend Timothy Collins.)

Davies agreed to donate the money to build the church and to lease the land on which the church would stand. In exchange, the thirteen families who had organized themselves as the Society of the Propagation of the Gospel in Foreign Parts agreed to pay Davies one peppercorn annually on the feast day of St. Michael the Archangel. Thus, the new congregation received its name. (A small marker stands along Route 202 near Baldwin Hill Road in Litchfield marking the spot where the first St. Michael's Episcopal Church opened its doors in 1748.) Mrs. Davies, however, did not share her husband's zeal for Litchfield. She wrote a friend that she was "entirely alone, having no society and having nothing to associate with but Presbyterians and wolves."

Being an Anglican was increasingly difficult in the Revolutionary War era. As the king was the head of the Church of England and Anglican/Episcopal parishioners took an oath of loyalty to both the king and the archbishop of Canterbury, the church became a target against which Patriots took out their frustrations with British policies. St. Michael's in Litchfield was forced to close its doors between 1777 and 1780. During one of George Washington's travels through town, some members of his cavalry escort threw stones at the structure until Washington, himself an Episcopalian, ordered them to stop. Some 20 percent of Connecticut's Episcopalians fled to Canada during the war.

One who remained was Reverend Samuel Seabury. Seabury, born in Groton, became the chaplain of the King's American Regiment, a Loyalist outfit, during the war. As the war ended, Seabury returned to Connecticut and swore his loyalty to the new American government.

In March 1783, ten of Connecticut's fourteen Episcopal clergy met at the Glebe House in Woodbury. This was the home of John Rutgers Marshall, minister of St. Paul's Episcopal Church. Here the clergymen chose a representative to travel to England in the hopes of securing an American bishop—and thus an American branch—of the Church of England. The group elected Jeremiah Leaming of Norwalk, but when Leaming declared himself too weak to make the trip, the clergymen turned to Seabury.

Seabury arrived in London in July but was forced to wait eighteen months as English bishops discussed whether they could consecrate a bishop who

Reverend Samuel Seabury, the first Episcopal bishop in the United States. *Library of Congress.*

would not swear loyalty to the English sovereign. Ultimately, Seabury took the initiative himself and traveled to Scotland, which had non-juring bishops who didn't recognize the king as the head of the Church of England. Seabury was consecrated as a bishop in Abderdeen in 1784 and returned in 1785 to Connecticut, where he worked to establish a separate American Episcopal Church.

At the height of the Great Awakening, a town meeting in Litchfield passed a unanimous resolution declaring that religious revivals were unwelcome in the town. While the Reverend Daniel Huntington said that Litchfield residents had "voted Christ out of their borders," the resolution was short-lived, as a new wave of religious revivals would sweep the town and the county.

If Litchfield County was relatively immune to the first Great Awakening, the county's revivals in the Second Great Awakening were described by the Reverend Samuel Dutton in 1798 as being "frequent and powerful" from their beginning "and have grown more frequent and powerful." Historians have identified multiple factors against which this second wave of revivals rose: immorality sparked by camp life in the Revolutionary War, the spread of deism and the influence of Catholicism from French soldiers in the colonies. However, the history of the revivals in Litchfield County predates most of these factors, with the earliest activities being traced to Woodbury and Sharon around 1770.

By 1799, Edward Dorr Griffin, pastor of Norfolk, reported that he could stand at his door "and number fifty or sixty congregants laid down in one field of wonders." Litchfield became a hotbed for revivals, with over half the town being swept up in them by 1799. People at the time spoke of a "Litchfield County Divinity." There were twelve separate periods of revivals in Cornwall between 1800 and 1860.

The numbers of participants in Litchfield County revivals are staggering. In 1815, Joshua Bradley wrote, "In Winchester, Norfolk, New Marlborough, Sandisfield, Goshen, Cornwall, and Salisbury, sinners hastened to Christ as clouds, as doves, fly to their windows. From the most accurate information received, I conclude that seven hundred were born again in these towns, in the course of the revival."

In Salisbury, the revival came at a low point in church membership. Male membership had fallen to about 20 before it soared to nearly 200 with the revivals. In 1816, 70 new members joined the Torrington church and 80 joined in Woodbury. In 1817, more than 100 joined the Harwinton church. In six revivals in Woodbury between 1830 and 1837, 163 new members flocked to the church.

These revivals took many forms: conferences, evening meetings, inquiries, visits to homes by clergy, etc. An 1831 revival in Norfolk provides a glimpse

Right: Lyman Beecher. *Library of Congress.*

Below: The Woman's Christian Temperance Union marker at the site of a public well in Thomaston. *Photo by author.*

into their operation. The revival lasted for four days, with ministers from neighboring towns coming to assist. Among the most noted of these visiting ministers was Asahel Nettleton, who began his sermons, "Lost, lost, lost!" There were sunrise prayers, public meetings and afternoon and evening preaching sessions. On the third day, full members of the church left for prayer while "anxious ones" took their seats to be addressed by the minister. The latter numbered 250 on the third day and grew to 300 by the final day. The revival concluded with all assembling for an address by the minister.

At the forefront of the revival movement was an appeal for an increase in morality. For example, in 1806, Reverend Ebeneezer Potter of Washington found a man dead in the snow with a bottle in his hands and preached on temperance. Many spoke out against dancing, and Sunday "blue" laws, once obscure, became revitalized.

No one in the county was more associated with this push for a greater morality than Lyman Beecher. Beecher came to the Litchfield Congregational Church in 1810 and immediately became the nation's leading advocate of temperance. Beecher described his time in Litchfield as the most "active and laborious of his life." Around 1814, he delivered his noted "Six Sermons on Temperance" (published in 1828).

The writer Theodore Parker stated that Lyman was the father "of more brains than any other man in America." The morality that Beecher attempted to instill in his congregation found its way to his children with varying degrees of success.

His daughters Catherine and Harriet Beecher Stowe became leading lights of the Cult of Domesticity, the widespread reform movements in the years leading up to the Civil War. His son, the famous preacher Henry Ward Beecher, was frequently accused of infidelity and was tried for adultery in 1875. The Litchfield County University Club erected a monument to the Beecher family on the Litchfield Green in 1908.

Beecher's work for temperance had long-lasting effects on Litchfield County. A visible reminder of the temperance movement remains in Kenea Park on Main Street in Thomaston, where a granite marker bears the letters WCTU. This was placed here by the Woman's Christian Temperance Union in 1902 to commemorate its installation of a hand-pumped well. The site was across the street from a popular tavern, and the well provided an alternative location for men to quench their thirst.

Henry Opukahaia. *Collection of the Cornwall Historical Society, Cornwall, Connecticut.*

Those caught up in the Second Great Awakening believed it was their mission to spread Christianity across the globe. One local manifestation of this was the establishment of the Foreign Mission Society of Litchfield County in 1813, the brainchild of Samuel J. Mills. At the society's annual meeting in 1815, Joseph Hawley of Goshen preached that the millennium would come within fifty years.

The society took on a new role with the arrival of Henry Opukahaia in Connecticut. Opukahaia (spelled Obookiah in his lifetime) was born on the island of Hawaii in 1792. His parents were killed in a civil war, and as a fifteen-year-old, Henry was taken aboard the merchant ship *Triumph*, commanded by Captain Britnall and bound for New Haven. While on board the ship, Henry befriended Thomas Hopu, a Hawaiian cabin boy who taught his fellow islander English.

While in New Haven, Opukahaia studied under Reverend Edwin Dwight, a recent graduate of Yale. In addition to the traditional curriculum of tutors and pupils of the time, Opukahaia focused especially on English grammar. During the course of his education, Opukahaia was exposed to Christianity, and he not only converted but also asked for training so that he could spread the gospel on his home islands. This resulted, in part, in the founding of the Foreign Mission School in Cornwall. Over its ten years of operation, the school educated one hundred students, including forty-three Native Americans and twenty Hawaiians.

While a student in Cornwall, Opukahaia worked on farms in Torrington and Litchfield to support himself. The Litchfield community encouraged Henry to systemize the Hawaiian language through the writing of a dictionary

and books on common grammar and spelling. Unfortunately, before these projects could be completed, Henry was diagnosed with typhoid fever by Dr. Calhoun of Cornwall. He died in February 1818. His last words were reportedly "*Alloah o e*," which translates to "My love be with you." Beecher presided over Opukahaia's funeral, eulogizing:

> *He came to this land and hearing of Him on whom without hearing, he could not believe, and by the mouth of those who could never have spoken to him in Owyhee.*

Opukahaia was buried in the Cornwall Cemetery, but in 1993, family members in Hawaii had his body reinterred at the Kahikolu Congregational Church in Kona, Hawaii. The Cornwall grave site is marked with a plaque thanking the community for caring for Henry and is topped with his words: "Oh! How I want to see Hawaii!"

———————

The first Catholics in Litchfield were three Acadians. These had been French residents of Nova Scotia at the time France ceded that province to England. While willing to take a loyalty oath to the king of England, they refused to fight for the English against France. Enraged, the English seized their property and expelled the Acadians from their homeland. They were forcibly dispersed among the American colonies. Over seven hundred made their way to Connecticut, where the general court allocated them to towns based on population. Three were sent to Litchfield, where they arrived in 1759; there is no record of them after 1760.

Large numbers of Catholics did not arrive in the region until the influx of Irish immigrants from the Great Famine of the 1840s. Norfolk, for example, had large numbers of Irish immigrants working at the J. & B.E. Ryan and Company wool mill along the Blackberry River. Mass would be held at the mill when Father James Fitton of Hartford was in town to officiate. Similarly, large numbers of Italian Catholic immigrants settled in the northwest corner of the county to work in the iron industry.

Among the most important aspects of the county's Catholic history is the tenure of Father Michael McGivney of St. Thomas Church in Thomaston from 1884 to 1890. Born to Irish immigrants in Waterbury in 1852, McGivney left school as a teenager to work in a brass mill. At sixteen, he

This plaque in Thomaston honors Father Michael McGivney, a candidate for sainthood in the Roman Catholic Church. *Photo by author.*

entered a seminary, and he was ordained a priest in 1877. While serving as a parish priest in New Haven in 1882, McGivney founded the Knights of Columbus as a means to strengthen the faith of Catholic men and to provide financial assistance to a family in the wake of a father's death. Today, the organization has nearly two million members, and the Catholic Church declared McGivney "Venerable," a step on the path toward sainthood. A plaque next to the entrance of St. Thomas Church honors McGivney.

Over the last two centuries, the Catholic Church has replaced the Congregational Church as the largest religious institution in the county. The 2000 census indicated that 53 percent of county residents identified with an organized religion; of that number, 65 percent identified themselves as Catholic.

This demographic shift is reflected in prominent Catholic religious centers that opened in the county in the twentieth century. One in particular stands

out. In 1947, the Abbey of Regina Laudis was established in Bethlehem, born out of the destruction of World War II. Mother Benedict Dunn was born Vera Duss in the United States but lived much of her early life in France. She spent most of the war in the bell tower of the Abbey of Notre Dame de Jouarre, from which she watched the advance of George Patton's liberating United States Third Army. The kindness and sacrifice of the soldiers led Mother Benedict to establish a foundation in the United States. The nuns were welcomed to Bethlehem by the artist Lauren Ford, who opened her home to the order until they could find a place of their own. A local industrialist named Robert Leather donated the four hundred acres that today compose the abbey. The abbey is noted for its Neapolitan crèche, which draws pilgrims at Christmas.

From the eighteenth-century "Pope of Litchfield County" to the Beechers to the Catholic pilgrims who make their way to Bethlehem each Christmas season, religion has been at the forefront of Litchfield County's history.

Chapter 5

Town Farms

There is much to learn about a town's history from the names of its roads. Litchfield, New Milford, Torrington and Woodbury all have roads named Town Farm Road or Old Town Farm Road (or both); Salisbury has Old Asylum Road. These names all give hints to a nearly forgotten aspect of New England history.

———⇒•⇐———

Connecticut's colonial legislature passed its first law concerning the poor in 1673. Seven years later, it reported to the Privy Council of England that "for the poor, it is ordered that they be relieved by the town where they live, every town providing for their poor; and so for impotent persons."

The expense that towns could accrue in providing for their poor led colonial townships to early on provide definitions as to what constituted a resident. The 1673 law specified that a resident was a person who had lived in the town for three months. Later laws in the colonial period stated that town residents could not increase the number of people in their household without gaining the permission of the town's other inhabitants. The records of early town meetings in Litchfield County reflect this. At one meeting in the 1740s, for example, Canaan admitted ten new families to the town.

Other laws and motions passed at town meetings looked to nip potential costs of providing for the poor in the bud. One colonial law made idleness a crime,

stating no one "shall spend his time idly or unprofitably, under pain of such punishment as the court shall think meet to inflict." Under such a law, those receiving aid from the town who were seen in taverns could be put in the stocks.

In 1740, Canaan approved a motion made by resident Joseph Walker that the town "take some spedy care to prevent unholsom In Habitence being sent Into ye town of Canaan as agents [*sic*]." Other towns passed laws limiting the length of stay for out-of-town guests. A later law imposed a seventy-dollar fine for bringing a pauper into a town. New settlers who were not approved by a town would be "warned out" by town leaders; while these settlers could not be forced to leave, they were put on official notice that they were ineligible to receive alms from the town. These provisions made moving to a new town a risky venture.

A pauper who did not have settlement would be provided for by the state but only for six months. After that, he was returned to the last town he had resided in for more than six months.

The risks caring for the poor posed to the financial well-being of Litchfield County towns in the colonial era were real. Several towns, including Barkhamsted and Goshen, petitioned the state in the 1740s to be released from their obligation of paying taxes to the state because they could not afford their local obligations. These included the minister's salary and upkeep of the church, costs associated with education, maintenance of local roads, the militia and care of the poor.

To minimize costs, provisions were adopted specifying that the indigent must exhaust all potential support from blood relatives before being eligible for town aid. In 1739, the Connecticut legislature mandated that an individual's family be responsible for their care regardless of the cause, whether poverty, mental illness or physical disability. Over time, the legislature further defined "blood relative," extending the obligations from parents to children, grandparents, grandchildren and, later, husbands.

Still, these were Puritan communities, descendants of those earlier settlers who believed they could be a "city on a hill," a beacon for how Christians should live. While concerned about the cost, they nonetheless set about devising the means to provide for all members of the community.

The earliest attempts at caring for the poor were through direct grants. This was soon replaced by the "vendue system," the same manner by which

estates were disposed of following the death of the owner. When used as a means of caring for the needy, the vendue system was sometimes referred to as "pauper auctions" or "outdoor relief."

The vendue master—the early records of Litchfield and Cornwall refer to vendue masters in the town—conducted auctions in which the lowest bidder would receive the right to care for a needy family. They would receive the amount they bid from the town. While there were minimal requirements that needed to be provided, the winning bidder secured the right to make use of the pauper's labor.

Historian Benjamin J. Klebaner provided a dramatic description of a vendue auction, which was often fueled by liquor supplied by the town: "Only a Hogarth could have done justice to the scene, a gathering of the town worthies, often at the village inn, generally after the annual meeting, at which the qualities of each pauper were detailed with the same callousness as that shown in discussing the merits of a horse—or a slave."

While the vendue system grew in popularity after the American Revolution, after the upheaval of war increased the burdens on the towns, as the abolitionist movement grew in the early nineteenth century, the similarities to slavery that Klebaner highlighted led many to push for an end to the system.

The solution was the town farm (sometimes called the "poor farm"), a tract of property with a structure large enough to house the town's needy. Historian Ryan W. Owen has written that the town farm was "often relegated to a far corner of town, unseen, forgotten, and hopefully self-sufficient." Advocates for the town farms hoped that in addition to being provided with the basic necessities, the inmates (as they were often called) would be rewarded for their labors with a feeling of industriousness.

Consistent with the attitudes of Victorian society, the town farms were based on segregation; men and women were rarely together, using separate living rooms, stairways and even different parts of the property. Equally important was the need to separate those inmates deemed to be of good character and at the town farm because of physical ailments from those considered immoral and especially intemperate. Chapter four discussed the connection between religious revivalism and a quest for greater morality in society. An 1834 analysis of Litchfield identified twenty-five poor in the town;

The Kent poor farm. *Collection of the Kent Historical Society, Kent, Connecticut.*

five of these were classified as observers of temperance, the temperance of three was doubtful and the poverty of seventeen was attributed to their intemperance or that of their relatives. The report also stated that for the previous four years, the annual expense to the town of caring for its poor had averaged $1,700. Adjusted for inflation, this represents approximately $50,000 in 2013.

Litchfield's town farm was originally located in the South Farms section of town, but when that area became Morris in 1859, Litchfield needed to find a new location to house its needy. The town purchased the 123-acre David P. Beach farm northeast of town the following year. A large structure was built in 1880; this still stands on the east side of Town Farm Road off Route 202.

The State Board of Charities and the State Board of Health inspected town farms annually. George Ingersoll visited the Litchfield town farm on behalf of the State Board of Health in 1894. His report gives the modern reader a glimpse inside a town farm:

Litchfield's town farm. *Collection of the Litchfield Historical Society, Litchfield, Connecticut.*

A bill submitted to the Town of Litchfield for the care of the Johnson family, 1839. *Collection of the Litchfield Historical Society, Litchfield, Connecticut.*

The Salisbury Asylum is in the background of this photo. Note how clear the landscape is of trees. *The Salisbury Association, Inc.*

The farm is located about three miles from Litchfield village. The Poor House, which is a commodious three-story wooden building, stands on a high elevation both healthful and attractive. We were courteously received by the matron and shown over the building. The first floor comprises the matron's apartments, kitchen, dining room and sitting rooms for inmates and hospital room. The sleeping rooms are on the second floor. The inmates' beds are provided with straw mattresses, sheets, blankets, and light feather beds. The rooms looked clean.

There are at present 10 inmates, 6 men and 4 women. They looked in good health and had no complaints to make. The matron reported no sickness since last winter when one of the inmates had the grip. We found the food served, fair and the water supply seemed pure. Privies for the men and women are connected with the main building by covered alley-ways preventing exposure of inmates in wet or cold weather. The privies were clean and had no great amount of odor. Stable and hogpen are located about 100 yards from the main building and were reasonably clean.

The Poor House is heated by three fair sized stoves on the first floor. Doubtless in winter the second story sleeping rooms are cold, but perhaps no more so than the inmates had previously been accustomed to sleep in.

A later report indicated that the Litchfield town farm had achieved self-sufficiency through the sale of its farm goods.

The Salisbury almshouse, known as the Salisbury Asylum, was described in a 1920 state report as

a very old farmhouse with few of the modern conveniences. When last visited there was no running water or bathroom in the house, but the place was provided with electric lights. In spite of the lack of conveniences, the house was well kept, and there was evidence that the inmates were given kindly treatment.

Litchfield County's towns take great pride in their past, and early histories exist for all of them. Missing from these, however, is almost any reference to the poverty that existed within their borders. Like the Board of Health and Board of Charities reports quoted above, governmental records exist to help the twenty-first-century reader better understand the workings of the town farms. For example, the 1860 census delineates the eighteen residents of the Salisbury Asylum. Hercules W. Thorpe, thirty-seven years old, was the keeper of the asylum, where he resided with his wife and two children. It appears that there were two other employees who lived at the facility, along with Philo Pierce, a child of eight who perhaps was in the care of the Thorpes. There were eleven inmates (seven male, four female), ranging in age from seven to eighty-three, and classified as being "paupers," "insane paupers" or "idiotic paupers."

Only nine of the county's twenty-six towns had an almshouse or town farm. Towns were permitted by state legislation to contract with other towns to house their poor or to combine with other towns to provide services. The 1910 census reported that Connecticut tied with New Hampshire for the highest rate of pauperism in the United States. (The census also provided statistical data on Litchfield County's poor. For more information, see Table 1.)

Table 1: Litchfield County Almshouse Population, 1910

Town	Number at Almshouse	Number of Men	Number of Women	Number of Foreign Born	Number of African Americans
Litchfield	10	4	3	4	0
New Hartford	3	2	1	0	0
New Milford	3	2	1	0	0
Norfolk	6	6	0	1	2
Salisbury	4	4	0	2	0
Sharon	10	4	6	1	0
Torrington	9	4	5	3	1
Winsted	7	4	3	4	0
Woodbury	7	3	4	1	1

As the twentieth century approached, Litchfield County's towns often looked to new means to provide for their poor. The town farms and almshouses were open only to recognized residents of the towns; those who were not longtime residents but were guaranteed town assistance by state laws were referred to as "outside poor." As town farms were often self-sufficient and the outside poor drew sizeable amounts of money from town coffers, a new system was needed.

Hiring the needy as daily laborers often did this. In 1890, for example, Litchfield reported to the State Bureau of Labor Statistics that it was paying outside poor $1.50 per day to work on the town's roads and had expended $1,573.25 in the previous year. Thomaston, which did not have an almshouse, instead contracted with families in town to house the "helpless poor" and paid the needy $2.00 a day to work on town roads. Winsted reported that "no paupers are employed on roads," but they were hired to chop wood to "keep them off the outside poor account." The town spent $111.45 on the largely self-sufficient almshouse but spent nearly $3,000.00 on the outside poor.

In 1935 and 1936, the Connecticut General Assembly and the United States Congress passed legislation granting pensions and Social Security, which provided aid regardless of one's official residence. This marked the end of the era of town farms. Litchfield's town farm, for example, was leased out to the Toll Gate Farm and ultimately sold in 1941.

Chapter 6

Education

The same Puritan ethic that led early Litchfield County towns to take care of their poor also pushed them to establish schools. The Puritan settlers who arrived in the New World in 1630 and settled Boston were highly educated, with many having professional careers. That these colonists moved to a wilderness and founded Harvard College within six years is testimony to the emphasis they placed on education.

These Puritans brought their educational system with them when they moved to the Connecticut River Valley. In 1650, the Connecticut legislature passed a law requiring that everyone be taught to read English and be educated in a trade. This law was motivated in part by the desire that all Puritans be able to read the Bible and thereby avoid the temptations of Satan. As such, colonial acts like this were known as the "Old Deluder laws."

By 1750, the law had been modified so that everyone was required to "read the English tongue well" and to "know the laws against capital offenses." Parents who didn't comply faced punishment. To carry out the law, the colonial government mandated that all towns with seventy families or more support a school and keep that school open at least six months a year. The geographic size of the towns, coupled with the poor transportation available to county residents, meant that several schools needed to be established in each town.

Some of the earliest recorded proceedings of town meetings in Litchfield County pertain to the establishment of public schools. Goshen was organized into four school districts in 1742. Torrington opened its first school in 1745,

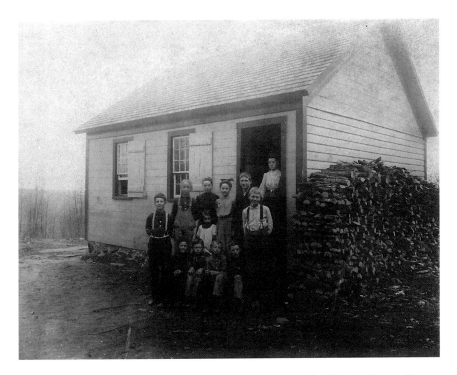

The East Kent one-room schoolhouse, 1907. *Collection of the Kent Historical Society, Kent, Connecticut.*

with the school building located within the walls of the fort that protected the town against Native Americans and French invaders. That same year, Salisbury created five districts, which within fifteen years were servicing nearly five hundred students.

These schools were the one-room schoolhouses of American lore. Prime examples still stand on Brooks Road in Goshen, Beebe Hill Road in Falls Village and in the center of Morris. Three outstanding examples—Northville; Hill and Plain; and Gaylordsville—have been preserved in New Milford. An unusual but beautiful one-room schoolhouse is the brick North West School on Brick School Road in Warren. This school remained open until 1924.

The average dimensions of these structures were twenty-four feet by thirty feet. Their most prominent features remain the double set of entrance doors and cloakrooms, one for boys and one for girls. New England schoolhouses were nearly universally described as being cold. In her history of New Hartford, Sarah L. Jones recounts a situation likely common in all district

schools in the county: "The school-houses were warmed by open fireplaces, supplied with wood furnished by the parents of the children in proportion to the number sent."

These schools, especially in the post–Revolutionary War era, served two fundamental purposes: to produce both literate citizens for the new republic and a literate flock for Congregational ministers. This was reflected in their curriculum. Salisbury's curriculum at the turn of the nineteenth century was typical: reading, writing, arithmetic and catechism. New Hartford's schools were classic grammar schools for nearly fifty years; no arithmetic was taught until 1812. When mathematics was finally introduced, Jones wrote, "slates and blackboards were unknown; the multiplication-table was orally drilled into the children, who were taught to make figures in their copy-books."

The district schools were highly successful in educating a vast citizenry in the fields deemed necessary for church and state to flourish. With the numbers of middle-class Americans rising dramatically in the early nineteenth century and the subsequent increase in aspiring college students, more rigorous academic opportunities were in high demand. Connecticut's School Law of 1799 declared that a "higher order" school could be established by a two-thirds vote of the town, but few towns agreed to spend the money on such an institution.

The answer was the academy, a private school dedicated to preparing students for college; in the case of Litchfield County academies, this was typically either Yale or Williams College. Academies were quite common; New Hartford had three in the nineteenth century, and even the county's smaller towns, including Goshen, Norfolk and Roxbury, had an academy. Litchfield had at least five. A small marker and the remnants of a foundation at the intersection of Routes 61 and 109 mark the location of the county's most notable, the Morris Academy, a landmark coeducational institution.

The academy was the brainchild of James Morris III, who was born on January 19, 1752, in South Farms (which, in 1859, was renamed Morris in his honor). Morris's father, James, was a deacon, and the son harbored hopes of entering the ministry. An enthusiastic reader, young James routinely traveled to Bethlehem to borrow books from that town's library. His education, which began with these library books, was guided by three remarkable teachers.

At eighteen, Morris began studies under Bethlehem's Dr. Joseph Bellamy, one of the leading theologians of the late eighteenth century. It is reported

that Morris also studied under Nathan Hale before enrolling at Yale. While at Yale, Timothy Dwight, later president of the university and one of the leading figures in American educational history, served as Morris's tutor.

After the war, he returned home and married Elizabeth Hubbard, with whom he raised five children. His fellow townspeople elected him both justice of the peace and a selectman. By 1790, however, when children began regularly showing up at his door, Morris put aside his ideas about the ministry and looked instead for a career in education.

Rare for his time, Morris accepted both boys and girls as students. This sparked significant discussion, as many believed that education would cause women to lose sight of their more traditional roles. In 1794, a town hearing was held about the situation, and any charges against Morris were dismissed.

By 1800, Morris's school had grown so large that a formal structure was needed. Wealthy subscribers were enlisted from the area to subsidize the $1,200 cost of the thirty-four- by thirty-six-foot building, which opened its doors to forty-seven boys and thirty-six girls on November 28, 1803. In time, Morris would educate students from all of the New England states except Rhode Island, as well as New York, New Jersey, Pennsylvania, Maryland, Virginia, South Carolina, Georgia and the West Indies. He averaged between fifty and seventy-five students a year.

That November, Morris took out an ad in the *Litchfield Monitor* advertising his school, which stated that he

> *is now furnished with a convenient building for the purpose, where will be Taught the English grammar, Geography, Mathematics, and Belles Lettres; also the Latin and Greek languages. A particular attention will be paid to the morals of those entrusted to his care; to aid which, religious instructions will not be omitted. A course of lecture will be given through each season of schooling on Moral Philosophy.*

While Morris died in Goshen in 1820 (he is buried in East Morris), the school remained open until 1888. As Barbara Nolen Strong wrote in her 1976 book on the school, "The Morris Academy is entitled to be called a pioneer institution because of its 'open door' policy in coeducation. It was not the first in the United States, not even in Connecticut, but none of the other early academies opened their doors as wide and kept them open as long. No other coeducational academy spread its influence so far."

The same revolutionary fervor that led to the growth of district schools and the emergence of academies also resulted in increased educational opportunities for girls. This was due to a desire for "republican motherhood," a belief that the daughters of Patriots had a responsibility to pass along the virtues and ideals of republicanism and civic duty to the next generation. While there were several academies for girls operating in the county, none was more influential or noted than Sarah Pierce's Litchfield Female Academy.

Pierce was born in Litchfield in 1767. She never married and instead dedicated her life to educating young women. Pierce's father died when Sarah was sixteen, and her brother, John Pierce Jr., invested in an education for his sister in the hopes that she would become a teacher and support herself. The first classes were held in the dining room of the Pierce home.

By 1798, Pierce had termed her school the Female Academy and begun a subscription list to build a structure, which by 1803 was erected at a site on North Street indicated today by a stone marker. Here young women were introduced to Pierce's revolutionary ideas about education—namely, that girls should be taught what boys were, including geography and history. Pierce went so far as to write her own histories when she couldn't find suitable texts.

At the turn of the nineteenth century, students were coming in such large numbers—130 in one year alone—that Pierce needed to hire additional teachers. The subjects they were responsible for grew to include chemistry, astronomy and botany. Academic pursuits were balanced with artistic endeavors including music, dancing, singing, embroidery, drawing and painting.

Pierce brought in her nephew John Pierce Brace, a graduate of Williams College, as a teacher and her ultimate successor as head of the school. Brace was noted for his hands-on approach to education, as noted by Mary Wilbor in 1822: "Mr. Brace had all his bugs to school this P.M. He has a great variety, two were from China, which were very handsome, all the rest were of Litchfield descent, and he can trace their pedigree as far back as when Noah entered the ark."

A watercolor of the Litchfield Female Academy by Emily Hart, circa 1856. This is a copy of an earlier painting of the school by J. Napoleon Gimbrede. *Collection of the Litchfield Historical Society, Litchfield, Connecticut.*

Pierce's students boarded with Litchfield families. The town featured several large boardinghouses, including Aunt Bull's on Prospect Street, and many families took in students from the Female Academy and the Litchfield Law School. Pierce was committed to teaching her students proper etiquette, as evidenced by the following rule: "You are expected to rise early, be dressed early, be dressed neatly, and to exercise before breakfast. You are to retire to rest when the family in which you reside request you. You must consider it a breach of politeness to be requested a second time to rise in the morning or retire of an evening."

Mary Ann Bacon attended Pierce's academy in 1802 and boarded with the Andrew Adams family on North Street. Her diary entry for June 14 provides insight into a typical student experience:

Arose about half past five, took a walk with Miss Adams to Mr. Smith's to speak for an embroidering frame. After breakfast went to school. I heard the Ladies read history, studied a Geography lesson and recited it. In the

afternoon I drew read and spelt. After my return home my employment was writing and studying I spent the evening with Mrs. Adams and retired to rest about half past nine o'Clock.

Over 3,000 young women—and about 120 young men—were educated at Pierce's school before it closed in 1833. Their intellectual, social and artistic abilities helped make Litchfield one of early nineteenth-century America's most cosmopolitan towns.

A different sort of academy was the Cream Hill Agricultural School founded by Dr. Samuel W. Gold and his son Theodore S. Gold in Cornwall in 1845. The school opened its doors with four students and rapidly grew to twenty, which was deemed its maximum size. Theodore Gold stated that the school's mission was to "unite, with classical and scientific education, theoretical and practical instruction in agriculture—to encourage a taste for the pursuits of rural life, to develop and strengthen the body as well as the mind."

Cream Hill Agricultural School in Cornwall. *Collection of the Cornwall Historical Society, Cornwall, Connecticut.*

While the school was dedicated to the teaching of agriculture, the broader curriculum included biology, chemistry, geography, humanities and mathematics. Students lived at the school and had meals with the Golds. Attendance was sporadic, as students often had to return to work at their family farms. When Samuel died in 1869, Theodore closed the school and became a trustee of the Storrs Agricultural School, the forerunner of the University of Connecticut. The Cream Hill Agricultural School buildings, meanwhile, have been moved to the grounds of the Connecticut Antique Machinery Association in Kent.

———◦◦———

For all the success of the county's academies, the vast majority of its students continued to attend the local district schools. The height of the district school era came at the end of the nineteenth century. In 1878, Litchfield County had 274 schools to serve 11,495 students. North Canaan, with 245 students, and Bridgewater, with 185, each supported five school districts, the smallest number in the county. Litchfield had the most schools, twenty, for its 691 students. Bethlehem operated eight schools for only 123 students. These schools were open an average of 169 days per year. In 1878, male teachers in the county made an average of $35.11 a month, while female teachers made $26.19.

———◦◦———

The school for the borough of Litchfield was located on West Street, but Arthur Bostwick, who was born in Litchfield in 1860 and became a prominent librarian and author, wrote that "nobody went to it who could afford a term's tuition at the Institute." (Here Bostwick refers to the Elm Park Collegiate Institute.) A great fire swept through Litchfield in 1886, causing severe damage to the town. From the destruction, which included the West Street school, an educational opportunity arose for the town. Two years later, a high school opened at the top of East Street. Students were required to study grammar, literature, arithmetic, United States history and geography.

By the early twentieth century, a movement was underway to combine the scattered school districts into "consolidated" or "center" schools. It was believed that this would offer students a more specialized education

at enhanced economic efficiency to the town. The result for Litchfield was Center School, which opened its doors in 1925, the bicentennial of Litchfield's first school. This anniversary was commemorated in the inscription still visible at the top of the building: "1725 First Public School Appropriation The Center School Litchfield Bicentennial building dedicated 1925."

Another result of consolidation was the creation of Housatonic Valley Regional High School in Falls Village and Regional School District #1. In the first third of the twentieth century, the six towns that compose Region One (Canaan, Cornwall, Kent, North Canaan, Salisbury and Sharon) each had their own high schools. William Teague, Connecticut's supervisor of

Eleanor Roosevelt at Housatonic Valley Regional High School's tenth anniversary celebration, 1949. *Courtesy of Housatonic Valley Regional High School.*

rural schools, recommended as early as the 1920s that the towns of the northwest corner combine into a single district in order to both save money and provide more educational opportunities.

In 1937, the state legislature authorized the formation of the new district, which became the first regional high school east of the Hudson River. The new school board purchased the seventy-five-acre former Lorch Farm, where Salmon Creek meets the Housatonic River, for $8,000. As this was in the midst of the Great Depression, most of the funds needed for purchasing the land, constructing the building and outfitting the classrooms were provided by the Public Works Administration. The school opened its doors to students in 1939.

<center>———◆———</center>

While all of this relates to elementary and secondary education, the county has a notable history of higher education as well. At the forefront was Litchfield Law School, founded in 1784 by Tapping Reeve.

Prior to Reeve's school, legal education was achieved either through an apprentice system (known as "reading law") or by traveling to England to participate in its system of reading and moot courts. Reeve and his later partner James Gould believed that the law should be taught as a science rather than a philosophy; that is, as something that could be applied to particular situations.

Reeve moved to Litchfield in 1773 and immediately made his mark on the local legal community. Early on, he took in his first student, his brother-in-law Aaron Burr, the future vice president. Reeve served in the Continental army, as county justice of the peace and as the state's attorney. It was, however, the careers of his early students—including Burr, secretary of the treasury and Connecticut governor Oliver Wolcott Jr. and prominent Connecticut politician Uriah Tracy—that made Reeve's name.

In 1784, Reeve ceased practicing law—although he would later be a judge—and erected a building on his South Street property to function as his school. The pedagogy of the school was constructed around a series of forty lectures given by Reeve and Gould. (It is interesting to note that Gould's lectures were given in a similar structure at his house on North Street.) The program was intended to last fourteen months, including two one-month vacations in the spring and fall. Tuition was $100, with an additional $60 payment due if a student wished to stay for a second year.

Tapping Reeve's lectern. *Collection of the Litchfield Historical Society, Litchfield, Connecticut.*

Lectures were typically ninety minutes long, and students sat at wooden desks and quickly took notes, which were later more formally transcribed into folios measuring nine and a half inches by seven and a half inches. A typical student filled five such folios during his time with Reeve and Gould. As many of Reeve's

students moved to the rapidly developing West, historian Daniel Boorstin has argued that these notebooks formed the first law libraries on the frontier.

What is inarguable is that Reeve was highly successful in grooming his students for legal careers. Litchfield Law School alumni included 28 senators, 101 United States representatives, 6 cabinet members, 14 governors, 16 state supreme court chief justices and 3 justices of the United States Supreme Court.

———»•‹———

An altogether different higher-education experience was Camp Columbia in Morris, which for nearly one hundred years—from 1885 to 1983—was operated by Columbia University. The five-hundred-acre campus for engineering and surveying classes occupied, at its peak, nearly one square mile from the shores of Bantam Lake to the Morris/Bethlehem town line. Here, engineering breakthroughs such as the concrete roof that would later top Madison Square Garden were pioneered.

Land purchases began in 1903. Prior to this, the university had rented land from Mrs. Everett Waugh. Mrs. Waugh's farm became the heart of the property, which soon featured dormitories, a YMCA building with billiards and ping-pong tables, a mess hall and an astronomical observatory. Columbia paid $10,000 for the 1903 purchases.

In 1917, officers' training for the United States Army took place on the property. Trenches were dug near Munger Lane, and mock infantry assaults swept the camp. In 1918, the university issued an informational packet for those interested in a second round of training at the camp that stated that the purpose was to offer "an officers' training course for men who may be called to the National Army and desire to fit themselves for officers of noncommissioned officers in Government Service."

In 1934, a fieldstone dining hall was built, and eight years later, the central feature of the camp, a sixty-foot cylindrical water tower with an observation platform made of local stone, was presented to the camp by the class of 1906. A 1952 Columbia University press release describes the tower as a "land-locked lighthouse, or the battlement of a feudal castle."

Columbia engineering students blasted and leveled the hilly terrain to create a softball field and football field. In the late 1940s, the Columbia Lions football team held its early season practices here under Coach Lou Little, who paced the sidelines at the school for twenty-six seasons and was

Camp Columbia. *Collection of the Morris Historical Society, Morris, Connecticut.*

inducted into the College Football Hall of Fame in 1960. Little was supported in his efforts by the then-president of Columbia, Dwight D. Eisenhower. Ike is reported to have spent time at the camp watching practices and hunting on the grounds.

Still, the primary purpose of the camp was as a field school for engineering students, and by the early 1950s, the summer program was mandatory for these students. Courses taught at the camp included chemical engineering, civil engineering and technology and international affairs. Additionally, the Columbia University American Language Center offered classes for those international students who wished to apply to American colleges. By the mid-1960s, however, declining student interest in the camp experience and changes to the engineering curriculum brought an end to the Engineering Department's use of Camp Columbia. Since 2004, Camp Columbia has been a state park, and the tower and a chemical storage building still stand.

Chapter 7

Industry

By the early 1800s, education in New England had undergone a transformation in which the curriculum at traditional grammar schools was expanded to include the study of mathematics. Part of the reason for this was the need for an educated workforce that could operate and repair the machinery of an industrial-based economy. By 1852, twenty-four "villes," sections of towns named for local industrialists—like clockmaker Eli Terry's Terryville—had appeared in Litchfield County. It would be impossible to discuss in totality the county's industrial heritage in this work; what follows is a sampling of the varied nature of Litchfield County manufacturing based on extant footprints on the twenty-first-century landscape.

———→•←———

While the county made significant industrial contributions to the War of Independence, the decades leading up to the Civil War marked the true arrival of the Industrial Revolution. By 1840, there were sixty blast furnaces and seventeen forge plants operating in Connecticut; most of these were in Litchfield County. They all used charcoal; in fact, approximately eight thousand bushels of charcoal per week were brought by oxen to each furnace. It took two hundred bushels of charcoal—the product of a quarter acre of woods—to smelt one ton of iron. At that rate, as historian Gerard Studley has determined, twenty-three square miles of forest a year were cleared to make charcoal for the furnaces.

Smoldering charcoal contributed to a haze so dense that it blocked out the sun in the northern parts of the county. *Collection of the Kent Historical Society, Kent, Connecticut.*

Modern residents and visitors to northern Litchfield County note the green, tree-covered hills and numerous state forests. This landscape, however, emerged only after the Great Depression, when the Civilian Conservation Corps spearheaded the planting of trees in those areas. At the turn of the twentieth century, the county's northwest corner was virtually bare of trees. They had been cut down for charcoal decades earlier; in fact, by 1840, the county's ironmasters were bringing in charcoal from Vermont, New Hampshire and Maine. The constant burning of charcoal in the iron-making process resulted in a perpetual haze of smoke that hung over the county for decades, the sun visible only as a red disc through the smog.

<div align="center">⟶◆⟵</div>

While the presence of ore and abundant wood for charcoal brought the iron industry to the county, it was the region's brooks and rivers that brought most of the other industries. Cheap and reliable, water powered the mills

that appeared across the county. In few places was the concentration of these mills as great as it was in the Milton section of Litchfield.

Originally called West Farms before the settlement's name was changed to reflect its changing economic base, Milton's Marshepaug and East Branch Shepaug Rivers attracted aspiring industrialists. As such, it repeated a pattern seen across Litchfield; while the central village remained the commercial, political and religious center of town, the boroughs—Bantam, Milton and Northfield—became the industrial centers because they had rivers.

Milton's original settlers were Justus Seelye, David Welch and Jeremiah Griswold, who arrived in the area from New Milford in 1740. Welch established a bloomery forge for iron making on the Marshepaug River north of town. Griswold dammed the river to create Milton Pond, which provided power to small industries downriver, including Seelye's sawmill.

A second dam, the Center Dam, was constructed where the Marshepaug crosses modern Potash Road, near the village green. In 1811, the two dams provided power for five sawmills, two gristmills, two bloomery forges, a blacksmith, a carding machine, two wood turners, a wheelwright, a coffin maker, a clock maker, a carriage works and several nail-making shops. The stones from the gristmills are displayed in front of Milton Hall and the Milton Academy.

Mass-produced goods from large factories made these small industries unviable, leading to a transformation of Milton's economy to one based on agriculture. There was, however, a return to industry sparked by the establishment of the Aetna Shear Company along what is now Shear Shop Road. This operation lasted into the twentieth century, as did the Clark carriage shop.

The water-powered mills that propelled Milton's rise as an industrial community were common sights in nineteenth-century Litchfield County, and several remain standing in the early twenty-first century. Notable among these are the Beeman/Woodruff mill along Route 45 in New Preston and one along Route 133 in Bridgewater. A glimpse of the interior workings of these mills is visible along Route 202 in the Bakersville section of New Hartford, where part of a belt drive mechanism remains along the road. This was used to change the direction of a belt from horizontal to vertical, allowing for the machinery of a mill to occupy more than one story.

———◆◆◆———

Few places better epitomize the mass production that marked the demise of Milton's industries than the clock factories of Terryville and Thomaston. These derived from the revolutionary work of Eli Terry, who changed the purchase of a clock from a luxury that only the wealthiest could afford (the eighty-dollar price tag on a made-to-order "tall" clock in 1800 would be the equivalent of thousands of dollars today) into a necessity. In fact, one English visitor, who went by the pseudonym Featherstonehaug, commented of Terry's impact, "Here in every dell in Arkansas and in every cabin where there is not a chair to sit in, there is sure to be a Connecticut clock."

Terry was born in South Windsor in 1772 and studied under veteran clockmakers Benjamin and Timothy Cheney. Terry reworked the Cheneys' design so that a clock could sit on a shelf. Twice a year, he ceased production to take his products on the road, selling his clocks (which featured a brass dial and second hand and displayed the phases of the moon) for twenty-five dollars.

Terry's years on the road taught him that while all homes needed a clock, only about 10 percent could afford one. By 1802, Terry had abandoned life on the road to solve the problem of making clocks within the means of all Americans. In this way, he presaged what Henry Ford would do for the automobile a century later.

Terry used a water wheel to power machinery that cut teeth into wooden wheels; he also orchestrated the marriage between the brass and clock industries, which became two of the largest in the state. In 1807, Terry signed a contract to produce the internal machinery for four thousand clocks. It took three years to complete the order, but when he sold them at four dollars each, Terry, not yet forty, had made enough money to retire. He sold his business to two other well-known clockmakers, Seth Thomas and Silas Hoadley. Thomas and Hoadley soon split, with each eventually producing his own version of the tall clock.

Terry did not stay out of the game long, and soon there were three Terry factories in Plymouth. By 1814, he had refined the process of clock making to the point where he could sell a thirty-hour shelf clock for fifteen dollars; in 1820, he sold six thousand of them. Terry did retire in 1833 at the age of sixty-one, selling the rights to his clock to Seth Thomas. While the name

Workers at Silas Hoadley's clock factory, Plymouth, circa 1850. *Collection of the Mattatuck Museum, Waterbury, Connecticut.*

Terry no longer appears on clocks, travelers on Route 6 between Plymouth and Terryville still pass the water wheel built by Eli Terry Jr., commemorating the industry that gave the latter community its name.

———◦———

The success of Terry, Thomas and Hoadley forced other clockmakers to consider alternative means of earning a living. One was Asa Hopkins of Northfield. The Hopkins family had used the power of the Naugatuck River to make spinning wheels, but Asa turned first to clocks and then, in partnership with Luke Lewis of Litchfield, began using his woodshop's turners to fashion wind instruments (especially flutes) prized for their craftsmanship.

While Hopkins sold his shop and moved to New Haven in 1836, the settlement that grew up around the factory—Fluteville—continued on with its own railroad station, post office and school. Ultimately, the Flood of 1955 brought about the demise of Fluteville. While the hamlet remained

A flute crafted in Fluteville. *Collection of the Litchfield Historical Society, Litchfield, Connecticut.*

dry during the great floods, the need to control the Naugatuck River led to the construction of the Thomaston Dam; the water held back by the dam engulfed Fluteville.

The rise of industry didn't eliminate older means of manufacturing. While Eli Terry was bringing revolutionary methods to clock making, Hervey Brooks of Goshen used more traditional means to become one of the county's important businessmen.

Brooks came to Goshen as a teenager in 1795 and served as an apprentice to a local potter, then worked in others' shops. At the age of forty, he opened his own workshop and kiln, which he operated for the next forty-five years. He was noted for his redware pottery, which he sold to country stores on consignment. He also loaded a wagon with his goods and traveled the countryside peddling his wares; he often engaged in trade or barter with his customers. Part of Brooks's significance lies in the fact that while his methods of conducting business were traditional, unlike his peers, Brooks kept extensive records, providing historians with insight into the workings of the economy in the early American republic.

Hervey Brooks's pottery wheel. *Collection of the Litchfield Historical Society, Litchfield, Connecticut.*

Brooks entered the pottery business at a time when competition from tin products and stoneware was compelling many potters to close their shops. While he constructed a twenty-four-foot-tall kiln made of approximately fifteen thousand bricks (which could reach a temperature of 1,900 degrees), after 1828, Brooks only fired one kiln load per year. Brooks continued to do this well into the 1860s, when he was in his eighties. He specialized in milk pans, cooking pots and jugs and was noted for stamping his name on each piece.

The Hervey Brooks pottery shop stood along what is now Brooks Road in Goshen. In 1961, the building was moved to Old Sturbridge Village, and a reproduction of his kiln was constructed next to it. Visitors can still see the beam where Brooks allegedly carved his initials.

Along Route 109 in Morris, barely visible to passing cars, is a marker denoting the site of the King Family Grist Mill. Gristmills were once a vital part of New England communities. While we usually associate gristmills with grinding wheat into flour, that was not typically the case in New England. Here, with the region's rocky soil, it was far more common for farmers to raise rye, corn and buckwheat to be milled. In fact, white bread was considered to be a luxury.

This gristmill, likely built in the 1830s, was initially run by the Loveland family, who operated the mill for nearly fifty years before it was taken over by the Kings. In addition to grinding grains, the families used water power to saw timber and for the fulling (cleaning) of cloth.

The Loveland/King mill used two circular stones to grind. Traditionally, both stones would have grooves cut into them to act as teeth. The grains would be poured over the bottom stone while water power was used to turn the top stone, grinding the grain into flour. One bushel of grain typically yielded thirty-five pounds of flour. Johnnycake was the most expensive product of the mill, as it required a special bolt made from silk, and it was a particular target of hungry mice.

A late nineteenth-century photograph of the King gristmill along what is now Route 109 in Morris. *Collection of the Litchfield Historical Society, Litchfield, Connecticut.*

Local farmers would bring their grains to the mill, and the milling usually took place while the farmer waited. The Lovelands were known to operate their mill until midnight to accommodate these farmers. Millers usually received a percentage of the grain as payment, and mills often served as commodity houses where grains and flour were traded.

Elijah King took possession of the gristmill sometime before 1874, and while he ran it successfully for some years, changes in farming techniques and the decline of old milling practices left him bankrupt. In fact, the prevalence of wheat flour from the Midwest and the advent of gasoline-powered engines to mill grains on the farm for animal consumption prompted historian Marilyn Nichols to write, "Obsolete is the old grist mill in Connecticut."

Whereas the King gristmilling operation went bankrupt because of competition, the nearby Throop family prospered because they diversified their industrial operation beyond milling. Joseph Throop settled in South Farms (now along 109 west of Morris; the site is marked by a plaque on a grindstone) in 1747. He soon erected a sawmill, then a gristmill and even constructed a water-powered spinning wheel. Generations of Throops

Water from this millpond powered the Throop family's business enterprises. *Collection of the Morris Historical Society, Morris, Connecticut.*

continued the family's enterprises, including one that gives us a glimpse into an interesting aspect of Connecticut's early economy: cider making.

Cider was an important outlet for farmers to turn a perishable product into a lasting one. Once it was barreled, cider was also easy to transport to markets. Recipes for cider were widespread in the nineteenth century, with most farmers having their own method. Some advocated cleaning the press; others recommended using the residue from previous batches to add flavor. While some recipes called for unripe apples, others used rotten apples. Some even called for grass to be mixed with the apples. Cider in the colonial era and the early republic was nearly always hard, and as the alcohol level was quite low, it was enjoyed by children and adults alike.

Cider making was immensely popular on Litchfield County farms. Records from Torrington indicate that in 1775, the population of 843 people produced approximately 1,500 barrels of cider. There were two major cider producers in Morris (then South Farms): the Harrison family and the Throops. Litchfield County also had 103 distilleries in 1810, many of which made apple beverages of higher alcohol content. As a comparison, New Haven and Tolland Counties together had 101 distilleries.

It is interesting to note that several of the county's major industrial sites became parks or natural areas. These include Burr Pond State Park in Torrington and Lovers' Leap State Park in New Milford.

In 1851, Milo Burr constructed a dam across mountain streams in northern Torrington. This led to the emergence of typical mill-based industries. In 1857, however, Gail Borden based a truly innovative operation in Burrville. Born in Norwich in 1801, Borden was deeply affected by witnessing the deaths of several children due to contaminated milk while on a transatlantic voyage. He discerned that through the use of vacuums and very high temperatures, bacteria could be removed from milk. Borden immediately abandoned his current business—producing spoil-resistant meat pies—and turned his attention to the production of condensed milk.

In 1857, Borden partnered with Reuel Williams to build the Burrville plant. The Panic of 1857 prevented the business from becoming profitable, and when Borden secured a partner, New York banker Jeremiah Millbank, the operation moved to upstate New York. Thus, while the Burrville plant was closed before the Civil War brought enormous profits

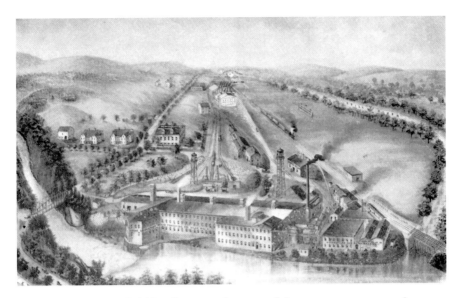

The Bridgeport Wood Finishing Company; the name of the company appears on the billboard in the distance. *From* Two Centuries of New Milford.

to Borden, the ruins of the plant can still be found on the grounds of the Burr Pond State Park.

Twenty years after the close of Torrington's Borden plant, the Bridgeport Wood Finishing Company began purchasing land in New Milford for a factory. The site the company selected at the junction of the Still and Housatonic Rivers provided excellent access to water power, which was used to power large-scale grinders. These were used to grind quartz and other materials into fine powder for use in stains, paints and their most noted product, Wheeler's Wood Filler.

The available water power allowed for production costs far below what they would have been had they used coal from Pennsylvania. Furthermore, the area immediately around the factory provided quartz, with additional quartz provided from nearby Southbury. The factory was built along the existing lines of the Housatonic Railroad, which provided the means to bring raw materials into the factory and ship the products out.

Bridgeport Wood Finishing products were extremely well regarded. They were displayed at the 1893 Chicago World's Fair—the famed Columbian Exposition—and even after the company was sold to DuPont in 1917, paints were still marketed under the brand name of Bridgeport Standard. In the 1920s, however, business turned sour, and the plant closed in 1927. At the

time, a newspaper noted, "Noonday in New Milford a few years ago was marked by whistle blasts at several factories. One by one those harbingers of industry have gone until now very few remain."

———◦———

The Great Falls of the Housatonic had been the scene of industrial activity since the eighteenth century. However, the purchase of the land by John Eddy, Horatio Ames and Leonard Kinsley in 1832 transformed the area into one of the county's leading industrial sites.

These men used puddling furnaces to turn pig iron made in blast furnaces into wrought iron. In this process, the iron is not in direct contact with the fuel, but rather, smelting is done with heat that reverberates (the furnace is sometimes called a "reverberatory furnace") through a chamber. The logs that supplied the heat were floated from Massachusetts and stopped by a boom that was laid across the river.

As Ames took control of the company, its fortunes increased. By 1850, 180,000 tons of wrought iron a year was produced at the location known as Amesville. The works employed eighty men, many of whom lived in company housing, shopped at the company store and had children who attended the Amesville school. A hotel was constructed for visiting associates. A horse-racing track was constructed nearby for weekend entertainment, with purses for particularly popular sessions totaling over $500, more than the average yearly salary.

And still the company continued to grow. The Housatonic Railroad ran a bridge across the river to connect the tracks on the east side to the factory. By 1857, the works had been increased to two double and four single puddling furnaces, with additional forges and the largest water-powered hammers in the United States being installed. More than two hundred workers toiled in two shops with a combined floor space of over thirty thousand square feet.

The coming of the Civil War seemed to offer unlimited opportunities for Ames, who poured the financial resources of the company into the research and development of new types of artillery. These were most often massive pieces of heavy artillery designed to fire shells that weighed fifty-six or eighty pounds. Abraham Lincoln himself took an active interest in Ames's work, writing to the ironmaster:

If you will, on or before the first day of March 1864, within the state of Connecticut, or at any point nearer this city, produce fifteen guns, each

The Beckley Furnace. *The Salisbury Association, Inc.*

of capacity to carry a missile of at least one hundred pounds weight, and notify me thereof, I will cause some person or persons to examine and test said guns; and if, upon such examination and test, it shall be the opinion of such person or persons, that said guns, or any of them, are, on the whole better guns, than any of like calibre heretofore, or now, in use in the United States, I will on account of the United States, accept said guns, or so many thereof as shall be so favorably reported on, and advise that you be paid for all so accepted, at the rate of Eighty five cents per pound, avoirdupois weight, of said guns so accepted; it being understood that I have no public money at my control, with which I could make such payment absolutely.

While Ames's cannon were highly regarded by the examiners, his product cost ten times those of his competitors. The company never recovered the money invested in development and went bankrupt in 1871. The works became the repair facility for the Housatonic Railroad. The foundation of that company's roundhouse is still visible along Housatonic River Road.

More successful was the Barnum and Richardson Company, which by the end of the nineteenth century was one of the world's largest iron producers.

Formed by Milo Barnum and his son-in-law Leonard Richardson in 1830, by the second half of the century, the company had consolidated control over all iron operations in northern Litchfield County, even owning its own iron ore mine. In 1870, Salisbury-area iron foundries produced ten thousand wheels for railroad cars.

However, the advent of the Bessemer process for steel production marked the decline of Salisbury's iron fortunes. Barnum and Richardson was sold to the Salisbury Iron Company in 1920, but this new organization stayed in business for only three years. The impact of the iron industry on the county was profound, however, and the Beckley Furnace purchased by Barnum and Richardson in 1858 still stands on Lower Road in East Canaan as Connecticut's official industrial monument.

As with many of the county's other industrial ventures, Litchfield's largest business also operated by water power. The Northfield Knife Company was established on Humiston Brook in Litchfield's southern borough in 1858, taking advantage of the water power and access to the Naugatuck

The Northfield Knife Shop. *Collection of the Litchfield Historical Society, Litchfield, Connecticut.*

Railroad. In the post–Civil War era, the company produced over twelve thousand knives per year. It employed 120 workers, many of whom were highly trained experts from Sheffield, England, then world renowned for its excellence in steel-knife production.

The mill dam brought other businesses to Northfield as well, most prominently a feed and fertilizer mill run by Jeremiah Peck. The growth of these two businesses led to a corresponding growth in Northfield's population, and factory housing appeared in town. In 1865, for example, the Northfield Knife Company spent $5,000 to erect five homes for employees on Main Street.

Northfield knives live on as Northfield UN-X-LD, a division of Great Eastern Cutlery. Today, they are made in Titusville, Pennsylvania. The millpond in Northfield remains, however, testimony to the industrial heritage of this area and to the Northfield Knife Company, an internationally known business whose knives were featured at the 1893 World's Columbian Exposition in Chicago.

In the days before refrigerators, foods either needed to be preserved (through canning, smoking or salting) or kept fresh through the use of iceboxes. Iceboxes depended on a steady supply of fresh ice, no easy proposition in the summer months. Ice was harvested from New England ponds and lakes in the winter to satisfy the demand.

The earliest ice harvests were done in the same manner as harvesting crops, with neighbors and friends pitching in and being compensated with a share of the crop. Specialty tools, including gang saws, chisels and saw plows, were used to cut the ice into blocks, which were then transported to icehouses for keeping. Icehouses were designed with the floor one foot off the ground to allow for the passage of air under the ice. They featured double walls, one foot apart and packed with shavings or sawdust for insulation.

The Berkshire Ice Company on Bantam Lake was the largest ice-harvesting operation in Connecticut. Its facility stood near the present Litchfield Town Beach on North Shore Road in Bantam. Here the foreman's house and machine shop still stand, and remains of workers' dormitories and the foundation of the massive 700- by 125-foot icehouse are visible.

The icehouse had fourteen thirty-foot-high storage sections that held a total of fifty-six thousand tons of ice. It took forty harvested acres of ice to

Berkshire Ice Company workers harvesting ice on Bantam Lake. *Courtesy of White Memorial Foundation.*

fill the warehouse. The particular challenge the workers faced was getting the ice into the storage house. This was especially difficult as the ice was cut into the three-hundred-pound blocks preferred for wholesale purposes.

Channels were cut into the lake, and the workers (who were paid sixty cents an hour and worked seven days a week in the mid-1920s) used poles to float the ice to a ramp upon which rested a conveyor belt. The concrete pillars of this system still stand as ghostly sentinels in the swampy grounds of White Memorial; the final pillars today support an observation tower on the shores of Bantam Lake.

The conveyor belts ran approximately one thousand feet from the lake to the icehouse. In the summer months, a spur of the Shepaug Valley Railroad ran from the Lake Station (near today's Cove Shops on Route 202) to the icehouse. Up to twenty boxcars a day were filled, and the ice was transported as far as Bridgeport. Alain White, in his *History of Litchfield*, described the "long trains," which "pull out daily in the summers, carrying concentrated relief from the Litchfield Hills to the larger cities southward."

The availability of electricity and refrigerators in the 1920s led to a severe decline in the demand for harvested ice. On August 8, 1929, a massive fire swept through the facility. Some have speculated that the fire was caused by spontaneous combustion of either the hay or sawdust at the site, while others reported that there were several cases of arson in the area. Either way, over

$350,000 in damages resulted from the destruction of the icehouse building, nine railroad cars and over fifty thousand tons of ice valued at $200,000. The next year, the Southern New England Ice Company sold its land to the White Memorial Foundation; as a result, the foundations remain to remind us of this once-vibrant industry.

———⊶◆⊷———

As older industries like iron manufacturing, ice production and quartz-based paint faded away, newer operations emerged in Litchfield County. The Bantam Ball Bearing Company was established in 1917 to meet the demand that resulted from the popularity of the automobile. Its factory, at the intersection of Routes 202 and 209, was first built in 1900 as the Bantam Manufacturing Company. In 1938, the Warren McArthur Corporation acquired the factory and transformed the area's industrial landscape.

McArthur's sleek design for metal chairs came to epitomize the art deco style of the late 1920s and 1930s. He operated his business out of Los Angeles, and upscale theaters and airlines used McArthur seats. Regardless of how chic his designs were, the company was not profitable, and McArthur was forced to rely on his father's fortune to keep the business afloat. When the elder McArthur died in the early 1930s, Warren moved the business to Rome, New York, and then to Bantam.

While art deco decreased in popularity, the lightweight and strong design of McArthur's chairs caught the eye of the War Department, and with the coming of World War II, the Warren McArthur Corporation was asked to make seats for bombers. The influx in orders led to a revitalization of not just the company but of Bantam itself.

The lathes and other equipment in the plant operated an average of sixteen hours a day and on occasion ran twenty-four hours a day. This resulted in a need for labor, and in an area still recovering from the Depression, workers from Morris, Torrington, Winsted and other area towns began commuting to Bantam. With shortages of gas, oil and rubber tires, housing within walking distance of the factory became an urgent need. By January 1942, the federal government had built twenty duplexes—what is now Circle Drive—off Route 209 and went on to build forty more. This represented a 33 percent increase in housing units in Bantam.

Even with the end of the war, the plant continued to make airplane seats. PTC Aerospace acquired the factory from Warren McArthur and built a

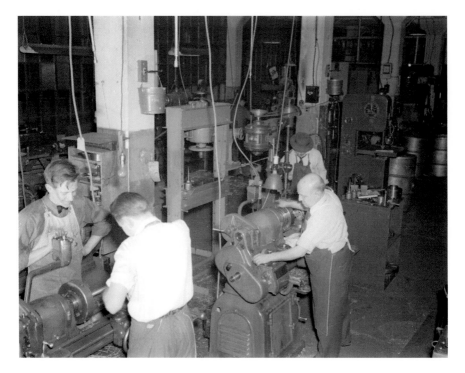

Workers at the Warren McArthur plant in Bantam during World War II. *Library of Congress.*

new facility on Route 202 in the 1960s but still kept the old factory operating until 1990.

In 2002, PTC closed its Litchfield County facilities and moved its operations to Northern Ireland, continuing a trend of the county's industrial history. Water provided cheap power to the county's early industrialists, but the need for proximity to the water limited the physical size of the factories and their access to transportation and raw materials. With the advent of cheap electricity in the 1930s, manufacturing firms left the area for more affordable land in the South and Midwest. The need for a highly educated workforce to construct and repair intricate mill designs was replaced by automated equipment and cheaper labor. Thus, in the early decades of the twenty-first century, we see many of Litchfield County's former industrial structures being converted to boutiques, artists' studios and fitness centers.

Chapter 8
African American History

The collection of the Salisbury Association holds a remarkable portrait of Maria Birch Coffing, daughter of iron maker George Coffing. A dour figure, she sits in a plain black dress, a simple brooch adorning her collar. What makes the painting extraordinary is the presence in the background of an African American woman, Jane "Jennie" Winslow. The back of a later photograph of Winslow states that she was "given" to Coffing when Winslow was five years old. As Winslow could not have been a slave under Connecticut law, she was probably Coffing's servant. The portrait is a powerful metaphor—relegated to the background for decades, there is a rich and important African American history in Litchfield County.

Slaves were among the first settlers of the county. John Buel, an early proprietor of Litchfield, enumerated a "Negro man named Martin worth 200 pounds" as his most valuable possession in 1746. Peter Pratt, the first minister in Sharon, owned at least two slaves. A census taken in 1774 reveals that there were 331 slaves living in the county, including 62 in Canaan and 80 in Woodbury. This number diminished over the decades. Northerners freed slaves in the wake of the Declaration of Independence, and slavery became less profitable in the North. Connecticut enacted gradual emancipation acts in 1784 and 1797, which required that slaves be set free at age twenty-five.

It is also important to note that the slave population of Litchfield County was considerably smaller than that of other Connecticut counties. Still, our modern conception of the county is at odds with the image of thirty-five slaves being held in Salisbury and with advertisements being taken out in

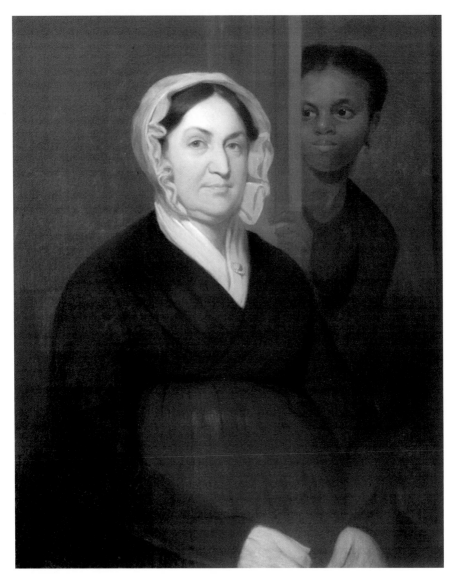

A remarkable portrait of Maria Birch Coffing of Salisbury, with Jane "Jennie" Winslow in the background. *The Salisbury Association, Inc.*

local newspapers for runaway slaves. For example, the October 23, 1805 issue of the *Litchfield Monitor* contained a posting by John Bird of South Farms for a fugitive who "ran away on the 21st instant about midnight, a man slave, by name Tom, who has long lived with my father, Doct. Bird." As

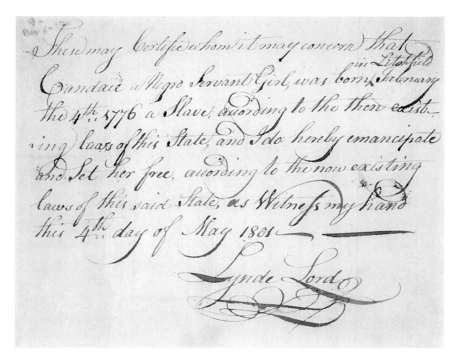

An 1801 emancipation document signed by Sheriff Lynde Lord for his servant, Candace. *Collection of the Litchfield Historical Society, Litchfield, Connecticut.*

the advertisement ran for three months, it must be assumed that Tom made his way to freedom.

Even as Connecticut passed gradual emancipation laws, the state showed greater concern for the economic prosperity of its white residents than freedom for the enslaved, as owners who wished to free their slaves needed to petition town officials and establish that their slaves were capable of supporting themselves. In 1801, in keeping with this law, county sheriff Lynde Lord certified that "Candace, a Negro Servant Girl, was born in Litchfield, February the 4th, 1776, a Slave according to the then established laws of this State, and I do hereby emancipate and Set her free, according to the now existing laws of this said state."

The vagaries of Connecticut's gradual emancipation laws played out in the story of perhaps the county's best-known slave. James Mars was born in Canaan

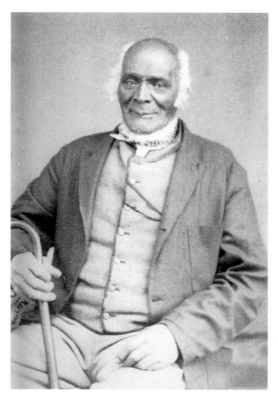

James Mars. *The Connecticut Historical Society.*

in 1790 to a slave owned by Reverend Thompson, minister of the town's Congregational church (who also owned Mars's parents, brother and sister). Connecticut's emancipation laws prohibited Mars from being sold out of state. However, when Thompson decided to move to his wife's native Virginia in the late 1790s, he was legally allowed to bring his slaves with him. This prompted the Mars clan to flee to Norfolk because there was, James later remembered, "an unpleasant feeling existing between the two towns or the inhabitants of Canaan and Norfolk," and while the people of Canaan would side with their former pastor in searching for the runaways, they would be safe among the people of Norfolk. Thompson first offered freedom to James's parents and sister if they turned over the more valuable sons, but this was refused.

Thus it was that James Mars and his family took to the woods and, with the help of people like a Mr. Cady and Captain Lawrence of Norfolk, eluded Thompson's pursuit. The minister eventually gave up and sold the rights to Mars to a local farmer named Munger and the rights to his brother to a farmer in Salisbury for £100 each, approximately $400. Mars later reported that while Munger was "fond of using lash," he grew to think "a good deal of Mr. Munger." Still, a dispute arose over Mars's mistaken belief that the enslaved were to be treated the same as white apprentices and freed at the age of twenty-one and not twenty-five, at which age slaves were to be freed. When Mars walked away from Munger, his owner threatened to put James in jail; ultimately, the matter was settled by arbitration, and Mars was allowed to buy his freedom for $90.

By the 1830s, Mars had married and was living in Hartford with his wife and two children. He worked in a dry goods store and was a deacon at the Talcott Street Congregational Church; he was also active in both the civil rights and temperance movements. In 1864, he returned to Norfolk and, frustrated to learn that many "did not know slavery was ever allowed in Connecticut," wrote his autobiography, which he sold door to door. He wrote that it was "my privilege and pleasure to help elect the lamented and murdered Lincoln." The autobiography went through six editions. Mars died in 1880.

William Grimes was born in 1784, the son of Benjamin Grymes, a wealthy plantation owner, and a female slave from a neighboring plantation. Ten different masters in Virginia and Georgia owned him before he was thirty years old. In 1814, he escaped by stowing away on a ship and made his way to New York and then to New Haven, where he worked as a servant and barber to students. In 1817, Grimes married Clarissa Caesar, with whom he had eighteen children, twelve of whom lived to adulthood.

Grimes ultimately made his way to Litchfield, where, he later reminisced, he "established myself as a barber. I very soon had a great deal of custom [*sic*], amounting to fifty or sixty dollars per month. After I had resided there for about a year with about as good success, I undertook to keep one or two horses and gigs to let." His customers were most frequently students at Tapping Reeve's Law School. (Reeve himself was known for defending fugitive slaves, most notably in 1780 when he joined Massachusetts attorney Theodore Sedgwick in representing Elizabeth Freeman, better known as Mumbet, one of the first slaves to win freedom in court.)

He supported his family through his work for the students and by operating a laundry and a livery. He earned between fifty and sixty dollars a month, more than double the average salary of a white worker at the time. Described as being "thrifty" and "frugal," Grimes purchased property on West Street, on the north side of the Litchfield Green, where he operated his barbershop.

Despite his success, Grimes was "warned out" of Litchfield by town fathers several times, indicating that since he was not born in Litchfield, the town would not care for him should he fall into poverty. Of this treatment Grimes later wrote that Litchfield's women have "societies to make clothes for those, who, they say, go naked in their countries. The ladies sometimes do

An image of William Grimes from the cover of the 1855 edition of his memoir. *The New Haven Museum.*

this at one end of a town, while their fathers, who may be selectmen, may be warning a poor man and his family out at the other end."

While they may have been hypocritical, these town fathers were also prophetic, for T.H. Welman, Grimes's master, discovered his whereabouts. While Grimes, with the assistance of Abel Catlin, William H. Thompson and Litchfield Law School students, raised $500 to attain his freedom from Welman, it cost Grimes his property and money. Still, Grimes later wrote, "Oh! how my heart did rejoice and thank God. From what anxiety, what pain and heartache did it relieve me!"

In an attempt to reestablish himself economically, Grimes published *Life of William Grimes, the Runaway Slave* in 1825 and updated it in 1855. It concludes with an extraordinarily powerful condemnation of American society's legal support of slavery: "If it were not for the stripes on my back which were made while I was a slave, I would in my will, leave my skin a legacy to the government, desiring that it might be taken off and made into parchment, and then bind the constitution of glorious happy *and free* America. Let the skin of an American slave, bind the charter of American Liberty."

Grimes returned to New Haven to do the same work for Yale Law School (which opened in 1824) students as he did for Reeve's. Grimes died in 1865 but was remembered in poem by Senator Albert Greene of Rhode Island, a graduate of Litchfield Law School, who wrote:

> *Old Grimes is dead—that good old man,*
> *We ne'er shall see him more;*
> *He used to wear a long black coat*
> *All buttoned down before...*
>
> *Thus undisturbed by anxious cares*
> *His peaceful moments ran,*
> *And everybody said he was*
> *A fine old gentleman.*

Unheralded in his own time, Milo Freeland of North Canaan has since been recognized as the first African American to enlist in the Union army. Living in Sheffield, Massachusetts, when the Civil War broke out, Freeland, a married twenty-three-year-old laborer, volunteered on February 16, 1863. Military

Milo Freeland of the Fifty-fourth Massachusetts Infantry. Freeland was reportedly the first Northern African American volunteer in the Civil War. *Florida State Archives.*

documents record him as being five feet five inches, with black hair and black eyes. He mustered into the Fifty-fourth Massachusetts, commanded by Colonel Robert Gould Shaw and destined to be made famous by the movie *Glory*.

Freeland survived the attack on Fort Wagner, near Charleston, South Carolina, where the regiment suffered approximately 350 casualties, and went on to fight at the Battles of Olustee, Honey Hill and Boykin's Mill. Freeland was mustered out of the army in August 1865 and returned to his wife in Sheffield. He appears in the 1880 census as a farmer; his wife, Sophronia, is listed as "keeping house." The couple had five children. In the last years of his life, he moved to East Canaan, where he died in 1883. He is buried in that town's Hillside Cemetery beneath a stone inscribed, "The First Colored Man enlisted from the North in The Rebellion of 1861."

Solomon Rowe was born free in Goshen in 1817, the son of a former slave. By the end of the Civil War, Rowe was the sexton of St. Michael's Church in Litchfield, a position that provided him with the means to buy a house (which was once the law office of Jedediah Strong, who constructed the mile marker along what is now Route 202) on North Lake Street.

A modern view of the Solomon Rowe house, Litchfield. *Photo by author.*

The Connecticut Freedom Trail identifies this as the only documented nineteenth-century residence in the county owned by an African American family. Rowe, according to historian Lynn Brickley, was said to have "enjoyed the respect in that aristocratic town for his personal character and dignified appearance." His home was always open to visitors, and his legendary hospitality was "without stint." Rowe's son George, born in Litchfield in 1853, apprenticed in the offices of the *Litchfield Enquirer* and became the first African American to obtain a certificate of trade in printing in Connecticut.

The decades after the Civil War saw Litchfield County increasingly become a destination for tourists and those seeking to escape the cities for the summer months. African Americans found employment in the area's hotels and restaurants, and the 1900 census lists 43 African American residents of Litchfield. Still, this was a considerable reduction from the census of 1830, when 137 African Americans lived in Litchfield.

Other black workers found employment with local municipalities doing road work in the summer and snow removal in the winter. Litchfield paid road workers fifteen cents an hour. Benefits were held in town to support traditionally black centers for higher education, including Hampton Institute, Fiske University and Tuskegee University. In 1898, Booker T. Washington came to Litchfield to raise funds for the latter.

However, the county's African American population continued to fall. The promise of factory jobs, the closure of many of the county's grand hotels and increased competition with European immigrants for employment resulted in the migration of African Americans to southern Connecticut. In the 2000 census, African Americans made up only 1.35 percent of the county's population; this decline in the demographic diversity of the county threatens the memory of the region's rich African American heritage.

Chapter 9
Civil War

Anyone who ventures into the cemeteries of Litchfield County is bound to stumble across the two words that evoked tragedy and mourning for residents of the mid- and late nineteenth century: Cold Harbor. June 1, 1864, was the deadliest day in the county's military history but was, in some respects, an event more than fifty years in the making.

<center>⊰•⊱</center>

An interesting perspective on the Civil War era is offered through the lives of two early nineteenth-century Litchfield residents. John C. Calhoun, born in South Carolina in 1782, graduated from Yale in 1804 and enrolled at Tapping Reeve's Litchfield Law School the following year after becoming frustrated with a law apprenticeship. Calhoun shared a room with his Yale classmate John Felder at the corner of West Street and Spencer Street but soon after moved to the home of Reuben Webster on Prospect Street.

Calhoun never enjoyed the law and began a political career almost immediately upon returning to South Carolina. He served in the state legislature and the United States House of Representatives and as secretary of war, vice president, secretary of state and a United States senator. For forty years, he was the preeminent voice in defense of Southern rights and of the institution of slavery.

Harriet Beecher Stowe in later life. *Collection of the Litchfield Historical Society, Litchfield, Connecticut.*

John Brown, a native of Torrington. *Library of Congress.*

That institution came under its greatest antebellum attacks at the hands of two Litchfield County natives. Harriet Beecher was born in Litchfield in 1811. Her father, Lyman Beecher, was the minister at the town's Congregational church. The family home stood at the corner of North Street and Prospect Street, very close to where Calhoun had stayed while attending the law school. A Connecticut tercentenary sign marks the site of the house. Harriet attended the Litchfield Female Academy from 1820 to 1824. While the family moved out of Litchfield, she remained in Connecticut, teaching at the Hartford Female Academy that her sister Catharine had established. Harriet moved to Cincinnati in 1834, married Calvin Stowe in 1836 and embarked on a writing career. *Uncle Tom's Cabin* was the product of her life in the Underground Railroad hotbed of Cincinnati.

The county's other great antislavery crusader was John Brown. Owen Brown, John's father, was a farmer and tanner who purchased a home on what is now John Brown Road in Torrington in 1799. While Brown had few memories of Torrington, his early years in the town were filled with remonstrances about the evils of slavery. For Owen Brown, it was not enough to simply be uninvolved with the peculiar institution; one needed to actively oppose slavery. And while the Browns moved from Torrington in 1805, this was a lesson his young son learned well and would carry out with violent consequences in Kansas in 1856 and, famously, at Harpers Ferry (then Virginia, now West Virginia) in 1859.

Brown has remained a controversial figure in American history. Was he a freedom fighter, looking to liberate those held in immoral bondage, or was he a terrorist? There is no doubt, however, that Torrington has celebrated its native son. An image of the Brown home is on the seal of the city; a mural depicting scenes of his life was created for the town's post office during the New Deal; drivers exiting Route 8 in downtown Torrington are welcomed to the city by a sign proclaiming it to be the "Birthplace of John Brown"; and the Torrington Historical Society partnered with the John Brown Association to purchase the site of the home—with the extant foundation—and erected a monument and interpretive markers.

As advocates for Northerners to take an active role in ending slavery, Brown and Stowe would likely have been pleased by their native county's role in the Underground Railroad. While much of the history of this secret route by which fugitive slaves were ushered to Canada is clouded in myth and legend, there is substantial documentation for a route that passed from the coast to Waterbury, then to New Milford, Washington, Torrington, Winchester and Winsted before crossing into Massachusetts.

Quakers took the lead in operations in New Milford, and the Old Friends' Meetinghouse, which still stands on Route 7 south of town, was a prominent center of activity. *Two Centuries of New Milford*, an early twentieth-century history, documented the role of other locations in town in the Underground Railroad:

> *In the later days of slavery in the South there were several stations of the Underground Railroad in this vicinity. Mr. Charles Sabin's house in*

Lanesville was one, and the house of Mr. Augustine Thayer on Grove Street in this village was another. Mr. Thayer and his good wife devoted their lives to the Abolition cause. They helped many poor slaves on their way, rising from their beds in the night to feed and minister to them, and secreting them till they could be taken under cover of darkness to Deacon Gerardus Roberts' house on Second Hill, from there to Mr. Daniel Platt's in Washington, and so on, by short stages, all the way until the Canadian border was reached.

A second prominent stop in Washington was at the home of Frederick Gunn, who established the Gunnery School in 1849.

As fugitive slaves reached Torrington, they likely sought refuge at the home of Isaiah Tuttle or his son, Uriel, who lived in the Torringford section of town. Uriel was president of the Litchfield County and the Connecticut Anti-Slavery Societies. Of his antislavery activities, Deacon Thomas Miller wrote, "His efforts and undying zeal in the cause of emancipation are too well known to the public in this state to need a delineation…His house was literally a place of refuge for the panting fugitive, and his purse and team were often employed to help him forward to a place of safety."

Other reported stops on the Underground Railroad include the home of Joshua Bird, a deacon at the Bethlehem Congregational Church who lived on the town green. Henry Terry, grandson of the clockmaker, lived on North Street in Plymouth. An ardent abolitionist, he allegedly had tunnels running from his cellar to an outbuilding to whisk slaves to safety. The presence of tunnels like these fed Southern fears about Northern complicity in helping slaves escape, and the belief that the election of Lincoln in 1860 would lead to legalization of the Underground Railroad was a major factor in the decision of Southern states to secede from the Union in the winter of 1860–61.

———>·•·<———

News of the secession of South Carolina did not immediately result in war fever. The January 3, 1861 edition of the *Litchfield Enquirer* proclaimed:

We cannot know what the year 1861 may have in store for us, but it is certain still, that through cloud and storms which threaten us as an undivided people now at the outset of the year, before the end a light shall

break upon us, the storm of strife shall cease, and after all we shall be a gain more firmly, a united and prosperous nation than we were, even when 1860 dawned upon us.

And even those who thought war was likely did not believe it would last long:

A very excited Democrat, one of the stiff and true blue, said in our office the other day that he would willingly and gladly be one of a hundred men from Litchfield to go down South and "mop those traitors clean out."...And we believe this to be the sentiment of every true Northern man, and every lover of his country by whatever name he may be known or called.

It was the Confederate attack on Fort Sumter that prompted a wave of patriotism. A 120-foot flagpole was erected on the Litchfield Green from which a 20-foot by 20-foot flag was flown. A meeting of representatives from across the county was held at the courthouse to declare sentiments "in favor of maintaining the Union and the Constitution at all hazards." The *Litchfield Enquirer* proclaimed the unanimity of support across the county for putting down the rebellion:

Eager knots of citizens gathered about the street corners discussing the affair, and but one sentiment animated all—Party distinctions were wholly lost sight of, and all Patriotic men, Democrats and Republicans, proclaimed a hearty devotion to the Union and for the upholding of the government. Such is the sentiment everywhere, throughout the country.

Events in June 1861 demonstrated that such sentiments were not unanimous across the county. Andrew Palmer of Goshen flew a secession flag from his house, which provoked an uproar in the community. When representatives of the town traveled to the home after church and asked him to take it down, Palmer, according to the *Litchfield Enquirer*, said he would continue to fly it and threatened to shoot any member of the committee "as quick as he would shoot a black snake." Then 150 men from town assembled with seventy guns and proceeded to Palmer's house; Palmer also had supporters, some of whom were armed. At least one shot was fired that hit one of Palmer's men in the leg. The secession flag was seized and an American flag raised. Palmer and his men were dragged to a town meeting, where they were released when they signed a pledge to never fly

the secession flag again and to "uphold and defend the Stars and Stripes." A second secession flag was supposedly flown in Cornwall, but it was removed after the Goshen incident.

On April 15, 1861—within days of learning of the Confederate firing on Fort Sumter—President Abraham Lincoln issued a call for 75,000 volunteers to serve for ninety days in order to put down the rebellion. Samuel Horne of Winsted was said to be the first man in Connecticut to enlist. While the response was overwhelming—volunteers had to be turned away when the ranks were filled—the battles at Bull Run and Shiloh and on the Virginia peninsula made it clear that significantly more Union troops would be necessary to vanquish the Confederacy. Therefore, in July 1862, Lincoln called for 300,000 additional volunteers to serve for three years. This number was more difficult to reach, and states were assigned quotas. Connecticut was thus required to raise 7,153 men for the Union cause. The state, in turn, assigned quotas to each town based on population and number of men already in the service. By this formula, Litchfield needed to raise 48 men in August 1862. If these quotas weren't met, a state draft would follow.

To plan on how to best meet the quotas, a "grand convention," composed of citizens from all over Litchfield County, met on July 22. This meeting decided to raise a "County Regiment," to be commanded by Sheriff Leverett Wessels, called "one of the best and most popular men of the county" by the *Litchfield Enquirer.* The convention also agreed to increase the size of the bounty offered by the towns to each volunteer to $100. (All told, the towns of Litchfield and Winsted would each award more than $50,000 in bounties, with a dollar in 1860 worth more than $25 today. One resident of Winsted, Elliot Beardsley, personally gave a bounty of $10 to the first one hundred volunteers from that town.)

A.B. Shumway, editor of the *Litchfield Enquirer,* was put in charge of the recruiting effort, and a tent—marked today by a granite monument—soon appeared on the Litchfield Green. Recruits soon turned out, encouraged perhaps by the fact that draftees would not receive a bounty. (Nor was there a guarantee draftees would serve; of the thirty men in Sharon who were drafted, twenty-nine hired substitutes. The only conscripted man to serve, William Chapman, died of disease in Washington, D.C., soon after joining the army.)

The enlistees from Litchfield and across the county reported to Camp Dutton on Litchfield's Chestnut Hill. One veteran, Theodore F. Vaill, remembered that "Camp Dutton was a beautiful spot, but no place for a regiment to learn its hard and ugly trade. Fond mothers and aunts raked the position with a galling and incessant fire of doughnuts, apples, butter, pies, cheese, honey, and other dainties not conducive to the suppression of the rebellion." Here, however, the men learned to pitch tents, fire their weapons and live as soldiers. Companies formed based on the towns of the majority of the enlistees:

Company A—Litchfield
Company B—Salisbury
Company C—Goshen
Company D—Plymouth
Company E—Winsted
Company F—New Hartford
Company G—Cornwall
Company H—New Milford
Company I—Woodbury
Company K—Composite of towns

(Civil War units avoided having a Company J, fearing it stood for "jinx.")

Whether its citizens were motivated by patriotism, financial incentive or fear of being drafted, Litchfield County exceeded its quota and raised a full regiment, which was christened the Nineteenth Connecticut Infantry. To do so, however, as Dudley Vaill wrote in his regimental history, "Litchfield County had given up the flower of her youth, the pride and hope of hundreds of her families."

On September 10, the regiment marched to town to receive its colors from Mrs. William Curtis Noyes, granddaughter of Revolutionary War hero Benjamin Tallmadge. The men were mustered into Federal service on September 11, 1862, and on September 15, after giving three parting cheers for Camp Dutton, they boarded a train of twenty-three cars at the Litchfield Station for New York. From there, they were sent to Washington, where instead of being assigned to combat duty, they were trained to man the large artillery pieces guarding Washington, D.C. This necessitated a name change, and the Nineteenth Connecticut Infantry became the Second Connecticut Heavy Artillery.

They remained in Washington for the next nineteen months, engaged more with fighting off boredom than Rebel invaders. In the spring of 1864, however, with General Ulysses S. Grant now in command of the Union armies, the Civil War became a war of attrition. To stem the falling manpower of his army, Grant summoned the heavy artillery units from the nation's capital. With their uniform coats free of the dust that had accumulated on

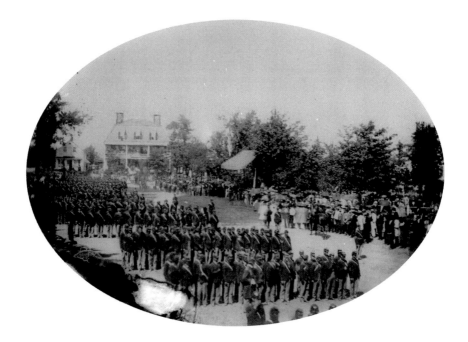

The Nineteenth Connecticut Infantry (later the Second Connecticut Heavy Artillery) mustering for service, September 1862. The building in the left background still stands. *Collection of the Litchfield Historical Society, Litchfield, Connecticut.*

most veteran campaigners, the Second Connecticut Heavies marched out of the nation's capital bound for the Virginia battlefields.

The Sixth Corps that the Second Connecticut Heavy Artillery joined on May 24 was a unit in mourning. Two weeks earlier, their beloved commander, Major General John Sedgwick, was killed at the Battle of Spotsylvania Court House near Fredericksburg, Virginia. Sedgwick, born in 1813, was a native of Cornwall Hollow. He attended the Sharon Academy and the Cheshire Academy before teaching for two years. Soldiering was in his blood, however (his grandfather and great-uncle were prominent officers in the American Revolution), and Sedgwick matriculated at the United States Military Academy. He graduated from West Point in 1837, ranked twenty-fourth out of fifty students. Commissioned a lieutenant in the artillery, he

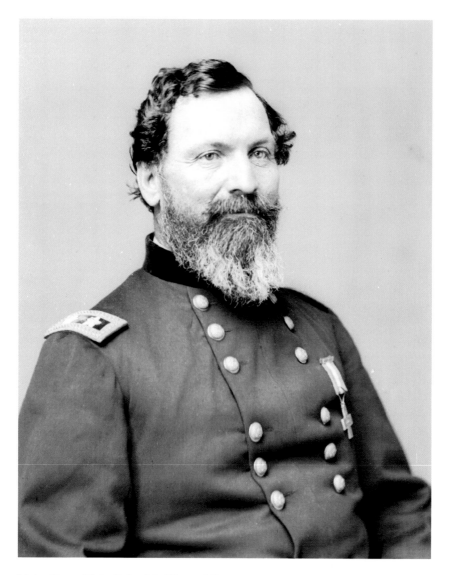

Major General John Sedgwick. *Library of Congress.*

served with distinction in the Seminole War and the Mexican-American War. Sedgwick's sister remembered his pre–Civil War service as being driven by "duty, stern daughter of the voice of God."

While serving in Kansas in the 1850s, Sedgwick learned that the family's Cornwall Hollow home had been destroyed in a fire. He took a leave of

absence and returned to Connecticut to build a new home. The Italianate-style structure still stands off Hautboy Hill Road.

Sedgwick rose rapidly in the early days of the Civil War, becoming a brigadier general in August 1861. One of his men described him as "an old bachelor with oddities, an addiction to practical jokes and endless games of solitaire." He led his men in some of the war's most famous battles, including Antietam (where he was wounded three times), Chancellorsville, Gettysburg and the Wilderness. By early 1863, he commanded the Sixth Corps, the largest in the Union's Army of the Potomac.

At Spotsylvania on May 9, 1864, Sedgwick was supervising construction of entrenchments when he noticed some soldiers dodging the fire of a distant sharpshooter. "What, what!" the general exploded. "Men dodging this way for a single bullet! What will you do when they open fire along the whole line? I am ashamed of you!" The general then recovered his good nature and, laughingly, proclaimed, "They couldn't hit an elephant at this distance." Almost instantly a bullet struck "Uncle John" just under the left eye, killing him immediately.

Sedgwick's body was taken to Washington, where a crowd assembled to see the procession go by. One woman, eager for a souvenir of the general, clipped two buttons from his uniform. From there, the body proceeded to New York and then to Cornwall Hollow, where two thousand family members, friends and neighbors turned out for the funeral.

In 1892, the Grand Army of the Republic dedicated an obelisk bearing a Greek cross, symbolic of the Sixth Corps, over his grave along Route 43. In 1900, Mr. and Mrs. Carl Stoeckel of Norfolk, friends of Sedgwick's sister Emily, donated a monument to the general across the road from his grave site. The monument features a bronze plaque of Sedgwick with laurel wreaths and lists the Mexican and Civil War engagements in which he fought. It also contains the inscription, "A skilled soldier, brave leader, a beloved commander and loyal gentleman. The fittest place where man can die is where man fights for man."

While Litchfield County mourned the loss of its most famous soldier, the men of the Second Connecticut Heavy Artillery were marching toward a small Virginia crossroads town, Cold Harbor. They joined the Army of the Potomac on May 24. They were now under the command of Elisha Kellogg,

Colonel Wessells having returned to Litchfield County with an appointment from Lincoln as the provost marshal for Connecticut's Fourth Congressional District. Kellogg, a native of Glastonbury and veteran of the British merchant fleet, was described by the *Connecticut War Record* as flaunting a "certain brusque roughness." This was on display on June 1, when the Union high command decided that one major push against the enemy line would shatter the Confederate army and open the door to Richmond. Kellogg, eager for the untested to prove its worth, volunteered the Second to lead the assault.

The colonel knelt on the ground and drew plans in the dirt, showing his officers how he wished them to advance against the Confederate earthworks. Major James Hubbard's battalion of Companies A, B, K and E would lead the assault. Kellogg stood in front of his men and reminded them that they had been called a "band box regiment," as their time in the Washington defenses made many believe that their role was to look the part at military parades. But now, Vaill remembered, he told the Second, "We have been called on to show what we can do at fighting." He urged the men not to fire a shot until they were within the enemy works and promised them, "I will be with you."

The men threw their backpacks behind the Union line and formed for battle. At 5:00 p.m. on June 1, the Connecticut artillerists-turned-infantrymen set out. Across confusing terrain and subjected to withering Confederate fire, confusion broke out. Union forces on either side of the Second veered off, leaving the Connecticut men to advance alone. Still, their line was, in the words of Captain James Deane of Company L, "as straight as if we were parading in a review." Advancing across a clearing into the woods, the regiment came upon the main Confederate battle line. Against a storm of lead, the men took shelter in captured Confederate rifle pits. This was no place to stay, however, and the order came to charge. As the Second surged forward, Confederate general Thomas Clingman ordered his men to aim low and saw "a tall and uncommonly fine looking officer in the front rank of the enemy's column, hearing the order and looking me directly in the face… [he] took off his cap and waved it about his head, cheering his men…Just as he had placed his hat back on his head…a soldier immediately on my right discharged his musket and the ball entered the upper part of his forehead." This was Kellogg, killed immediately while leading his first charge.

Confederate counterattacks struck the front and both sides, and casualties began to mount. Staff Officer Martin T. McMahon noted the dead "marked in a dotted line an obtuse angle, covering a wide front, with its apex toward the enemy." Clearly, Grant's belief that one more push would shatter the Rebels

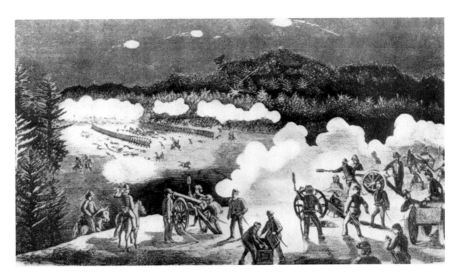

An artist's rendering of the charge of the Second Connecticut Heavy Artillery at Cold Harbor. *From White,* History of the Town of Litchfield, Connecticut, 1720–1920.

was tragically wrong, and the Second was on the verge of breaking. Into the maelstrom rode Brigade Commander Emory Upton, shouting, "Men of Connecticut, stand by me! We MUST hold his line!" Upton re-formed the men, and they helped repel a Confederate counterattack. The regiment, having suffered over 300 casualties including 141 dead and wounded, would never again have its military credentials questioned.

Unimaginable grief hit Litchfield upon receipt of the reports from Cold Harbor. Mrs. Hubbard, wife of Congressman John H. Hubbard of Litchfield, recalled:

> *You can have no idea of the intense anxiety in the days following Cold Harbor…The telegraph wires had more news than they could carry. It was impossible to get details. All we knew was, that a terrible battle had been fought and that a great number were either dead or wounded. As Mr. Hubbard was a Congressman, our house was a rendezvous for people hoping or fearing for news. They would often stay till late at night. I particularly remember one woman from Goshen who waited till eleven o'clock, and then went home, cheered with the thought that no news was good news. She had just gone home when we received word that her husband was among the slain.*

West of the center of Litchfield, in the area then known as Harris Plains (where Litchfield Ford is now located), were six farmhouses to which one or more of the men who had gone to war were brought back dead. George Kenney of Litchfield wrote, "Such funerals as we had in those days!" Nowhere was it worse than at the Wadhams house, for that family had three sons fall in Grant's campaign. One recollection helps put the scale of the tragedy into perspective. In the days after Cold Harbor, Deacon Charles Adams of the Litchfield Congregational Church, his own son mortally wounded at the battle, was kept busy traveling from the telegraph office in the center of town to homes in the surrounding countryside with the unenviable task of bringing the news of a son's death to the parents. He had journeyed out to the Wadhams house to break the sad news of one son's death and was on his way back to town when a rider approached and told Adams that he needed to turn around, for another Wadhams son had fallen.

<hr/>

Still, the war went on. Dorence Atwater was only sixteen when he enlisted in the Second New York Cavalry, lying about his age to join the Union army. He served as a courier, running messages, until he was captured during the Gettysburg Campaign in July 1863.

Initially imprisoned at Belle Island in Richmond, Atwater was soon transferred to the notorious Camp Sumter, better known as Andersonville. He fell ill in March 1864 but recovered to become a record keeper. While this removed him from the regular prison population, Atwater's task was a morbid one, recording the names of the men who died. The young man from Terryville, still only nineteen years old, was consumed with ensuring that, in the words of a *Hartford Courant* article, "family members would know the fate and final resting spot of their loved ones."

Atwater was paroled from Andersonville in March 1865 and, upon leaving, smuggled the camp's roll out in a bag. The punishment, had he been caught, would have been extreme. After the war, Atwater returned to Andersonville with Clara Barton to locate and mark the graves. In all, approximately thirteen thousand Union prisoners died at the prison camp. For his actions, Barton reported to family members, "For the record of your dead you are indebted to the forethought, courage, and perseverance of a 19-year-old soldier named Dorence Atwater."

Atwater's continued efforts on behalf of the victims of Andersonville—in this case protecting the list of names from those who wished to use it for

commercial purposes—resulted in his court-martial. Barton, however, took Atwater's case directly to President Andrew Johnson, who not only pardoned Atwater but also appointed him U.S. consul to the Seychelles Islands. He followed this by serving as U.S. consul to Tahiti, where he met and married his wife, an island princess. He also engaged in several highly successful business enterprises, including establishing a shipping line.

Atwater and his wife returned to Terryville in 1908 to view the monument the town had erected in his honor in Baldwin Park. The monument had been dedicated one year earlier, with his great friend Clara Barton in attendance.

Many of Litchfield County's veterans returned home in August 1865. Following Cold Harbor, the men of the Second Connecticut Heavy Artillery participated in the Shenandoah Valley Campaign of 1864 and the Siege of Petersburg and pursued Lee's army to its surrender at Appomattox Court House. Slowly, they made their way home. In the summer of 1865, a great

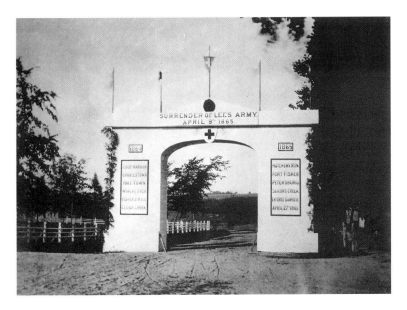

The victory arch erected on East Street in Litchfield to honor returning Civil War soldiers, August 1865. *From White,* History of the Town of Litchfield, Connecticut, 1720–1920.

celebration in Litchfield honored returning veterans from the county. The village was decorated with enormous national flags, while the smaller flags of a dozen army corps flew from the giant pole on the green. A triumphal arch, made of papier-mâché, was erected on East Street, where the Litchfield Historical Society now stands. It had the Sixth Corps flag in the center and two divisional flags on the side, below which were the battles in which the Second Connecticut Heavy Artillery fought.

The returning veterans—three to four hundred strong—paraded through the arch, soldiers on one side, civilians once again on the other. At dark, an illumination allowed the festivities to continue until the lights went out at 10:00 p.m., when the crowd dispersed.

The monuments to Sedgwick and Atwater were built during the peak era of Civil War monumentation. The fact that 40 percent of all Union dead were unidentified posed a particular problem for Americans. Death held a central place in the culture of Victorian America, and many hoped for a "good death," in which the deceased expired in his own home, surrounded by loved ones. The deaths of hundreds of thousands of Americans in the prime of their lives at great distances from their homes and families was therefore at variance with the notion of the "good death."

One solution was the effigy grave, a memorial stone for a victim whose body—because it was unidentifiable or for financial reasons—was unable to be returned home. The Civil War graves grouped together in Litchfield's West Cemetery (with a monument of a drum labeled "Mustered Out") are a good representation of effigy graves.

Another solution was the town monument to the men who sacrificed their lives that the nation might live. The process of monumentation began early on; Northfield began planning for its Civil War monument only months after Lee's surrender at Appomattox, and it was dedicated in 1866. Winsted's Soldiers' Monument and Memorial Park took longer to plan.

The initial steps toward erecting the monument started with the town's Grand Army of the Republic (GAR) post in 1870. Disagreements over the site and design, however, brought the project to a halt. In 1887, the GAR handed off the plans and funds to the Winchester Soldiers' Memorial Park Association, directed by Henry Gay. The following year, three men—John Rockwell, Caleb Camp and William Camp—donated land atop Crown

Effigy graves in Litchfield's West Cemetery. *Photo by author.*

Street, and fundraisers (including a "People's Fair") and wealthy benefactors procured the $15,000 needed for the memorial park.

The result was spectacular. The Connecticut Historical Society has written that "the design, materials, and craftsmanship of this exceptionally fine and little-known work all attest to the remarkable artistic and practical resources of provincial Connecticut." It features a sixty-three-foot-high Gothic Revival tower topped by a soldier carrying a flag tattered by the experiences of war. The interior consists of three floors. The first contains a fireplace and dedication plaque, the walls of the second bear the names of more than three hundred area men who fought in the war and the third contains space for exhibits.

The monument was dedicated on September 11, 1890—twenty-eight years to the day after the men of the Nineteenth Connecticut mustered into service—and a crowd of twenty thousand, including Governor Morgan Bulkeley, himself a Civil War veteran, turned out. The *Hartford Courant* referred to the event as "Winsted's Glorious Day." The glory, however, belonged to the veterans, and the monument remains a fitting tribute to those men who gave, as Lincoln put it, "the last full measure of devotion."

Chapter 10

Railroads

The movement of manufactured goods and troops was only made practical by the development of a railroad network in the county. It is interesting to note, however, that because Connecticut had an existing and vast system of canals and turnpikes, its railroad ventures had to be prompted by neighboring states looking to move goods and passengers through the Land of Steady Habits.

The first locomotive-powered railroads in the United States appeared in the mid-1820s. Within ten years, plans were in the works to bring railroads to Litchfield County. At the peak, much of the county was serviced by four railroad lines: the Housatonic, which connected Bridgeport and the Massachusetts border and ran roughly parallel to today's Route 7; the Connecticut Western, which connected Hartford to Poughkeepsie; the Naugatuck, which connected Devon on the Long Island Sound with Winsted, with a separate spur allowing access between Waterbury and Watertown; and the Shepaug, which ran from Hawleyville to Litchfield. In addition, Terryville had a station on the New York and New England Railroad.

Most of these railroads began at the ports on the sound and were constructed to bring goods to the state's interior. The exception was the Housatonic, which was constructed to bring the products of the northern reaches of the county—particularly iron and granite—to the ships at Bridgeport. As we have seen with road construction, the first railroads in the area were constructed through the north–south river valleys; transportation east and west required crossing rugged terrain.

A nineteenth-century canal in Washington. *Collection of the Gunn Memorial Library and Museum, Washington, Connecticut.*

Construction costs of the state's railroads ranged from $16,000 to $43,000 per mile. The state legislature banned direct public aid for building railroads, allowing only the purchase of stock with dividends that

would be tax free until profits reached a level of stability, usually 6 to 8 percent. Individual towns, which stood to greatly benefit from inclusion on a railroad line, were often the most eager to purchase stock or loan money to the railroad companies.

—————

The Housatonic Railroad was chartered in 1836, and in their haste to complete it, the promoters, in the words of historian Robert F. Lord, "threw caution to the wind," the result being that sound construction practices were "ignored or at best overlooked." An 1854 report by the state railroad commission found that "station houses and buildings on the line are of cheap construction." Part of this was due to financial difficulties, as construction began in 1837, the year of a nationwide economic panic. The City of Bridgeport issued bonds to fund the railroad and then defaulted, and the state refused to intervene.

Still, progress on the "Ousatonic," as it was identified in its application for a charter, continued, and the line opened between Bridgeport and New Milford in February 1840, with a band playing on board a railroad car bedecked with banners and flags. One newspaper reported that the train was "welcomed by several acres of people," and historian Samuel Orcutt wrote that "church bells were rung with much earnestness and the old cannon located on the rocks below the village poured forth its thunder of welcome to the railroad screaming steam whistle." The celebrations were merited; Litchfield County, long subjected to isolation, was establishing regular contact with the outside world.

By 1842, all seventy-four miles of track between Bridgeport and Canaan were complete. In 1850, the Housatonic connected with the Western Railroad of Massachusetts, which provided service to both Albany and Boston. In fact, it was the Housatonic that first established a rail connection between New York City and Albany. That same year, Alexander H. Holley of Salisbury, a railroad promoter, reported that between 150 and 200 passengers utilized the Housatonic every day, in addition to its carrying iron, granite and large quantities of milk. The Housatonic had regularly scheduled milk trains equipped with hundreds of forty-gallon cans in cars specifically designed for transporting milk. In 1850, the railroad reported $126,989 in revenue from transporting passengers and $170,081 when transporting freight. In 1890, these numbers increased to $529,854 and $796,368, respectively.

The Amesville repair facility of the Housatonic Railroad. *The Salisbury Association, Inc.*

At first, fire-burning engines powered the locomotives on the Housatonic. In 1856 alone, the Kent station went through 145 cords of wood, and the New Milford station used 350. The railroad paid fifteen cents per cord.

A passenger run from New Milford to Canaan took one hour and eleven minutes, while a train carrying a mixture of passengers, freight and milk could take up to four hours, forty-six minutes to make the same run. Within Litchfield County, there were stations at Still River, New Milford, Boardman's Bridge, Gaylordsville (Merwinsville), South Kent, Kent, North Kent (Flanders), Cornwall Bridge, West Cornwall, Lime Rock, Falls Village, Pine Grove and Canaan.

The New Milford station, constructed in 1886 at a cost of $15,000, survived the fire of 1902, welcomed President Theodore Roosevelt the same year and still stands today. Teachers and students frequently used the Boardman Bridge station. The Pine Grove station was established to bring visitors to the nearby Methodist retreat camp.

It was the Merwinsville station in what is now the Gaylordsville section of New Milford, however, that best epitomizes the opportunities brought by the railroad. Sylvanus Merwin owned a hotel in the area when the railroad was being laid out in 1837. (Roswell Mason, who would later be

Theodore Roosevelt speaks to a New Milford crowd from the back of a railroad car, 1902.
New Milford Historical Society and Museum.

A group waits alongside the tracks for a train to arrive at the Merwinsville Hotel.
Merwinsville Hotel Restoration.

mayor of Chicago during the Great Fire, did the surveying.) Learning of the proposed route, he agreed to sell land to the railroad in exchange for his hotel being a designated meal stop on runs between Pittsfield and Bridgeport and his being named the agent for the ticket office that would be located inside the hotel.

This arrangement continued, and Merwin prospered, until 1877, when a dining car was added to the train. Following Merwin's death in 1884, his son-in-law Ed Hurd ran the hotel for summer visitors and for dances but eventually was forced to close the hotel. He remained ticket agent, however, until the railroad decided to replace Hurd, which necessitated closing the office and establishing a new one; the area was renamed Gaylordsville.

The Central New England Railroad, originally the Connecticut Western, was the dream of Egbert Butler of Norfolk, who worried that his hometown would be isolated with no possibility of economic growth without a railroad. He paid for a survey himself and secured influential promoters, including Alexander Holley and W.H. Barnum of Salisbury and William Gilbert of Winsted.

Construction began in 1869, and despite the difficulties of crossing the mountains from east to west, the line was completed in 1871. Included on the route was a stop at Norfolk Summit, 1,333 feet above sea level. The line went bankrupt in 1880 and spent much of the rest of its tenure in financial difficulty or reorganization.

Still, the railroad provided an important means of moving goods across the state and to New York. It also helped promote Norfolk and Salisbury as summer residences. Mothers and children often spent summers on Twin Lakes, while fathers would visit on weekends. Boats met them at the station and took them across the lake.

In Canaan, the Central New England and the Housatonic Railroads intersected. The station there was, according to a local newspaper, "furnished with every convenience and…in the most modern style." It was topped by a weather vane shaped as a steam locomotive, which was created by workers at the Amesville repair shop and given to the town. The station was most notable, however, for the pies served in its restaurant. These were the work of Ada Nicoll, who was famous for her apple, rhubarb, lemon meringue and pumpkin varieties.

Few enterprises better exemplify both the high hopes and deep fears people had for railroads in the nineteenth century than the Shepaug Railroad. Edwin McNeil surveyed the line in the 1860s, despite threats put forth by armed farmers. Construction began in 1870, with one crew starting in Litchfield and another in Hawleyville (Newtown). The route was noted for being particularly winding, as it ventured around mountains and rivers. In one stretch, the presence of between 150 and 200 curves necessitated thirty-two miles of track to cover seventeen miles as the crow flies. It also required a 235-foot-long tunnel in what is now Steep Rock Preserve in Washington Depot.

A passenger train that left Litchfield at 6:25 a.m. reached Hawleyville at 8:00 a.m., where a connecting train reached New York City's Grand Central

The Shepaug tunnel, today part of the Steep Rock Preserve in Washington Depot. *Collection of the Gunn Memorial Library and Museum, Washington, Connecticut.*

A crossing sign from the Shepaug Railroad. *Collection of the Gunn Memorial Library and Museum, Washington, Connecticut.*

Station at 10:33 a.m. The line also transported iron, granite, manufactured goods and ice from the county's icehouses. The line went bankrupt twice in its first fifteen years; merged with the New York, New Haven and Hartford in 1898 (all the state's railroads were eventually part of this line, known as "the Consolidated"); and ceased operations in 1948.

———◆———

The emergence of railroads provided opportunities for county residents, but not all welcomed them. Ratchford Starr purchased Echo Farm on Litchfield's Chestnut Hill in 1873. He stocked the farm with thoroughbred Jersey and Alderney cattle and became the first milk producer in the country to bottle milk for shipment and distribution by train. Using the Lake (Bantam) and Litchfield stations, by 1881, he moved four thousand quarts of milk a day to urban markets.

Trolleys presented another opportunity. A streetcar line was opened between Canaan and Great Barrington, Massachusetts. Another operated between Torrington and Winsted. Debate broke out when two such lines were proposed in Litchfield in 1897, one to Torrington and another from Watertown and Norfolk. Supporters included workers hoping to get to factories, those who wished to expand tourist opportunities in town and

An artist's representation of the Echo Farm bottling operation. *Collection of the Litchfield Historical Society, Litchfield, Connecticut.*

those looking for greater access to goods and services. Opponents expressed concern over an "undesirable class of passengers," commenting in an anonymous letter to the *Litchfield Enquirer* that "where the electric line goes, there go picnics, pleasure parties, and the like which far too often result in lawlessness and disorder."

When another opponent commented that the traffic and noise of the streetcars would chase away the summer crowd that was looking for tranquility and that these seasonal residents were rapidly becoming some of the town's biggest taxpayers, a Torrington merchant responded that Litchfield residents were "haughty" and spent too much time tracing their genealogy. Litchfield's Village Improvement Society firmly rejected any plans for streetcars by 1905.

If railroads brought opportunity to the county, they also brought tragedy. In 1911, nineteen were injured when a train jumped the track one mile south of Washington. In 1913, a milk car rammed a passenger car in Canaan; eighty-six-year-old Mrs. Frank Olin was killed in the crash. Mrs. N.H. Blake of

The 1944 train wreck along Hatch Pond in South Kent. *Collection of the Kent Historical Society, Kent, Connecticut.*

Cornwall Bridge was holding a one-year-old at the time of the collision. The baby was thrown from her arms but was caught by F.C. Sprague. Sprague, Blake and five others were injured.

Perhaps the most notable railroad accident in the county took place along the Housatonic tracks in South Kent. On August 28, 1941, a six-car train with 254 young campers aboard returning to New York City from the Berkshires derailed along Hatch Pond. Two engineers—Theron Dixon of Danbury and Harold McDermott of West Stockbridge—were killed instantly. Otto Klug of Seymour, the train's fireman, was pinned beneath a car, trapped in five feet of water. Children held his head above water while an improvised halter was constructed. Doctors arrived from Danbury and amputated Klug's leg, releasing him from under the car. The accident could have been far worse except that it was lunchtime and most of the children had gone to the dining car, one of the two cars not to derail.

———◦———

Except for occasional freight trains, the days of rail service in Litchfield County have passed. An observant eye, however, will notice the berms, now devoid of tracks. Particularly good examples can be seen as one drives toward Norfolk on Route 272. These offer testimony to an earlier age when the region's industrial goods rode the rails to the outside world.

Chapter 11

Fire

Fire was an ever-present danger in Litchfield County towns because they featured compact village centers with nearly all the buildings made of wood. In nineteenth-century America, a "fire bell in the night" was a sound of terror; without modern firefighting equipment or effective transportation, a fire was likely to destroy whatever wooden buildings it touched.

This was the case in Litchfield in 1886 and again in 1888. The first fire began at 1:30 a.m. on June 11, 1886, in Moore and Maddern's General Store, which stood on West Street next to the Mansion House, a large hotel on the corner of West and South Streets. A *New York Times* article on the fire reported that "the flames spread rapidly, there being no adequate means of fighting them." The fire, which burned both south and west from its origin, was extinguished only when it had burned all the flammable structures it could reach.

The reporter wrote, "During the fire the town was wild with excitement. Men, women and children thronged the streets, but after the first building was destroyed it was evident nothing could be done. With nothing better than buckets, a battle with the fire was hopeless, and realizing this, the people watched the flames pass from house to house and prayed that the whole town not be destroyed." Another account stated that townspeople armed only with wet umbrellas raced into the buildings to save valuables.

At the Mansion House, attorney Henry Prescott of Litchfield barely escaped from his smoke-filled room. While the hotel guests managed to exit the building with most of their possessions, the structure itself burned to the

Ruins of the Litchfield fire, 1886. On the left stood the Mansion House. *Collection of the Litchfield Historical Society, Litchfield, Connecticut.*

The recently formed Litchfield Fire Company, 1892. *From White,* History of the Town of Litchfield, Connecticut, 1720–1920.

ground. The *Times* opined, "It is fortunate that the blaze did not occur during the height of the season, when it certainly would have been accompanied by serious loss of life."

Farther west, Lord's Block between the hotel and the courthouse was also destroyed, with three stores and offices going up in flames. And while the county records were rescued from the courthouse, that building was also destroyed. Thirty feet west of the courthouse stood a brick building; here the westward progress of the flames was at last halted.

On South Street, the Phelps Bottling Company, from which, according to the *New York Times*, "most of Litchfield County's thirsty citizens get the comforts of life," was destroyed, as was a jewelry store, a bakery, the public reading room and Wessels and Smith's clothing store. Attorney H.B. Graves's collection of rare and valuable books and Dwight Kilbourn's historical library were also lost to the flames.

The town's business district, according to one apt description, was "simply cleaned out." Estimates of the cost of the destruction ranged between $60,000 and $200,000, an amount that, adjusted for inflation, would be in the millions of dollars in the early twenty-first century. As word of the conflagration spread, curiosity seekers from as far as Hartford and New Haven poured into town, many driven by rumors that their property had been destroyed.

One particularly touching moment occurred when Sylvester Spencer, who had once owned the Mansion House but had fallen on hard times and was living at the town farm, was brought to view the ruins. A reporter from the *Springfield American* commented that "the landlord and the house are once more on a level."

Eight buildings were totally destroyed and twenty others damaged. Also ruined by the fire were the stores' inventories, which had recently been stocked for the summer season. Temporary buildings were assembled on the green to accommodate merchants. Court proceedings were temporarily relocated, and the town received an ultimatum to either rebuild the courthouse or see judicial operations permanently moved to New Milford or Winsted. The town chose to rebuild, at a cost of $13,000.

Tragically, that courthouse was destroyed twenty-six months later when a second fire swept through the town, this one beginning on the lower end of West Street and burning to the courthouse. The new structure had just been painted, and it is likely that this helped accelerate the fire. Town fathers revoked all building permits for wooden structures and rebuilt the business district in brick and stone. The Phelps Block, built by merchant and real

estate developer Eugene Phelps, replaced the Mansion House. With five shops on the ground floor and an opera house on the top floor, it was the crown jewel of the rebuilt town; the stone carved with "Phelps Block 1887" still bears witness to the town's recovery from the fires.

By 1889, installation of a water system had begun in town, and a fire company was organized. Deming Perkins donated a building to store fire equipment that was also equipped with a pool table, reading room, hospital and weather station. As such, it served as a club for the company's membership.

On May 5, 1902, a fire broke out in a stable behind the New Milford House hotel on Railroad Street in New Milford. Swirling winds soon spread the blaze in all directions. Soon, the Young's Hotel was afire, and the winds prevented the town's fire company from keeping up with the conflagration. The south side of Bank Street caught fire, and then the inferno jumped to the north side.

Finally, New Milford firefighters, aided by a crew and engine from Danbury, brought the blaze under control. This was done too late, however,

Aftermath of the 1902 fire in New Milford. Note the new construction taking place. *From Two Centuries of New Milford.*

to save three of the town's hotels: the New Milford House, Young's Hotel and the New England House. Two banks, the post office and some of the town's largest commercial enterprises, essentially the town's entire business district, were also destroyed, and the railroad station was damaged.

In all, the fire caused $100,000 in damages. As in Litchfield, temporary structures were erected on the green to store goods and to allow merchants a place to conduct business. While the town would be reconstructed in brick, iron and stone, it was still largely in ruins when President Theodore Roosevelt visited the town that September.

This was the second major fire in New Milford in 1902. In February of that year, the Bridgeport Wood Finishing Company's factory, a massive structure along the Housatonic near Lovers' Leap, went up in flames. Due to high winds and the intensity of the blaze, a bucket brigade that had been assembled could only work to save the other buildings at the complex. The total cost to the company was estimated at $100,000.

Multiple fires also victimized Winsted. At 4:00 a.m. on January 24, 1889, a fire broke out at the Lamphear and Alfred building that destroyed two blocks of the city. Among the businesses devastated were the Apothecaries Hall, variety shop, Belden's photographic gallery and studio and Birch's jewelry store. While firefighters and equipment were brought in from Torrington by train, the fire still caused $45,000 in damages.

A more severe fire erupted on August 2, 1908. "Incendiaries" stored in the town's wooden armory apparently caused it. More than three thousand rounds of ammunition were housed in the building, causing a massive conflagration. Blazing shingles blown off the roof of the armory ignited the roofs of a dozen other buildings, some of which were a quarter of a mile away.

The Odd Fellows building, a housing structure, stood opposite the armory, and eighteen people needed to be rescued from its third-story windows. The walls of the building began to collapse, adding to the danger. One resident, Lucy Eaton, refused to leave with the firemen until she had first saved her silverware. Allegedly, complete disaster was averted only because the Boston terrier of William Brennan woke his owner by barking and Brennan then roused the other tenants.

When the flames were extinguished, five merchants and nine families had lost everything. Losses to the town were estimated to be $80,000. As

Volunteers battle a fire in Winsted, 1909. *From the F.H. DeMars Collection.*

Litchfield County's towns grew in size, fire posed an increasing danger. In order to combat this, steps needed to be taken to harness the best resource available to fight it: water.

Chapter 12

Transformation

Until 1880, Litchfield had more residents than Torrington. Litchfield's population, however, had been in decline since 1820, a trend that would continue through 1910. During this period, the town lost more than 25 percent of its inhabitants. There were many reasons for the exodus from Litchfield. Across New England, populations fell in the aftermath of the American Revolution as farmers gave up their rocky lands for the promise of new lands in the West; the migration was so severe that editorials appeared in the *Hartford Courant* asking who would tend to the graveyards of Litchfield County in the aftermath of the departure of so many people. The drop in Litchfield's population was due to perhaps a simpler cause—it was very difficult for those who lived in town to obtain an adequate supply of water.

After discussions of how to solve the water crisis—and the continued decline in the town's population—the Litchfield Water Company was established in 1891. The company proposed damming Fox Brook in Goshen to create a reservoir. While water was brought to Litchfield in 1891, within a few years, the source was proven to be inadequate, for as Alain White wrote, Fox Brook "could not properly be called a brook, as it practically dried up soon after a rainfall."

Professor Henry S. Munroe, of Columbia University's Department of Mining, oversaw the construction of a new pumping plan in the valley below the reservoir, with wells ninety feet deep. These wells, as White wrote in his history of Litchfield, "have provided an unfailing supply of pure water ever

since, so that however dry the season or how near a water famine many of the surrounding towns were, Litchfield people...had no cause for worry." The reliable supply of water also allowed for the town to establish its fire department. To celebrate the town's salvation from the dearth of water, the Village Improvement Society erected a monument on the west end of the town green.

The Litchfield Water Company soon after purchased five hundred acres of the surrounding watershed of the reservoir, which it allowed to return to a natural forested state. In doing so, the water company became part of a movement that continues to this day, one that has seen the county transform from an industrial area to one noted for its serene landscape.

Among the county's first environmentalists was Alexander Lyman Holley, a steel magnate who looked to halt the impact of industry on his hometown of Salisbury. The celebrities and artists who have long been attracted to the area have also been prominent supporters of land conservation, and nearly every town in the county has a land trust. Some of these trusts are extraordinarily active; the Weantinoge Heritage Land Trust, for example, has preserved over four thousand acres of land, mostly in Litchfield County. The results of this movement have been profound. Perhaps the best example comes from George Black's book *The Trout Pool Paradox*, in which he laments the Naugatuck River south of Torrington as a "chemical sewer," while the Shepaug River is the "Platonic ideal of a trout stream."

Water played other important roles in the county's burgeoning environmental movement. In 1926, Connecticut Light & Power (CL&P) proposed construction of a lake for use as a reservoir in an electricity-generating project. The result was Lake Candlewood, the largest lake in the state, covering 5,420 acres in the towns of New Milford, Sherman, New Fairfield, Brookfield and Danbury.

Enormous penstocks, thirteen feet in diameter, were erected to pump water from the Rocky River area along the Housatonic uphill to the valley. (These

The Candlewood Valley being flooded by Connecticut Light and Power, 1928. *Collection of the Sherman Historical Society, Sherman, Connecticut.*

penstocks are still visible to passersby on Route 7.) The ensuing lake allows CL&P to run water down the penstocks through turbines when the water level in the river falls below a certain level.

To create the lake, thirty-five families were dislocated—most from the community of Jerusalem—and over one hundred buildings, including schools and churches, were demolished. Workers were paid one dollar per grave to exhume and reinter bodies from cemeteries in the path of the water. Over 1,400 workers contributed to the lake's construction.

A similar story played out in Barkhamsted. By 1930, it was apparent that the Nepaug Reservoir no longer satisfied the water needs of the Hartford area. With the construction of the enormous Saville Dam (named for Metropolitan District Commission chief engineer Caleb Miles Saville) on the east branch of the Farmington River, the Barkhamsted Reservoir stretched to eight miles in length, providing thirty billion gallons of water to Connecticut's capital and its suburbs.

While it was initially difficult to convince residents to leave their homes, the increased severity of the Depression forced the holdouts to sell. Many

of the one thousand who were displaced ended up working on the project, which began in 1936 and resulted in a filled reservoir in 1944 and thousands of surrounding acres returned to nature.

The water needs of the city of Waterbury resulted in the establishment of the Shepaug and Upper Shepaug Reservoirs in Warren and the Pitch, Morris and Wigwam Reservoirs in Warren. A remarkable feature of this reservoir system is the tunnel, over seven miles long, that carries water via an aqueduct from the Shepaug Reservoir under Bantam Lake to the Pitch Reservoir. Built between 1921 and 1926, the tunnel stretches for 1,125 feet under the lake from what is now Camp Hope to Marsh Point. The tunnel is 7½ feet high, and progress proceeded at 10 feet per day. Track was laid on the bottom so that a battery-powered locomotive could remove the excavated material. To protect the water supply, the City of Waterbury and water companies purchased thousands of acres around these reservoirs.

Man's inability to control water also played a vital role in the county's transformation. The Flood of 1955, the worst natural disaster in Connecticut history, resulted from the approximately two feet of rain dropped by Hurricanes Connie and Diane that August. The Housatonic stood at twenty-four and a half feet deep, and the Mad and Still Rivers in Winsted raged at fifty miles per hour. In Torrington and Winsted, buildings were uprooted and put on top of one another. The Shepaug River carried away an apartment building in Washington Depot. Concrete sections of Route 44 were washed away, and across the county, Bailey bridges—made famous during World War II—were used to provide temporary river crossings. Twenty-five helicopters searched for survivors or dropped clean food and water. Statewide, eighty-seven people were killed, and over eight thousand buildings were damaged or destroyed.

In addition to severely (in some places irreparably) damaging the state's industrial infrastructure, the floods forced the U.S. Army Corps of Engineers to take action so that such a disaster never happened again. The army constructed the Thomaston Dam (1960), Northfield Brook Dam (1965) and Colebrook Dam (1969) at a cost of $70 million. The Naugatuck River, with its many tributaries, had been especially prone to flooding, and the dams constructed along that river provided over seventy-seven thousand

Flooding along the Shepaug River in Washington Depot. *Collection of the Gunn Memorial Library and Museum, Washington, Connecticut.*

acres of flood capacity, while returning over one thousand acres to forest. This protection came at a price, however, as construction displaced the communities of Fluteville and Campville.

It was in 1908, the last full year of Theodore Roosevelt's presidency noted for its conservation initiatives, that Alain White, fishing on the Bantam River, turned to his friend William Mitchell Van Winkle and said, "Wouldn't it be wonderful to preserve this river, lake and countryside as we see it now?" Thus began a truly remarkable career in land conservation, one that would lead Connecticut Park and Forest commissioner Donald C. Matthews to remark, "No person or organization has given so much for conservation in Connecticut as Alain and [his sister] May White."

Margaret "May" and Alain were two of John Jay and Louisa White's five children. A wealthy New York businessman who specialized in real estate, John

A painting of Love Grove, allegedly by noted western artist George Catlin, from Mary Wallace Peck's friendship album. *Collection of the Litchfield Historical Society, Litchfield, Connecticut.*

Boys from Camp Wonposet at the ruins of the Bantam icehouse following the 1929 fire. *Collection of the Morris Historical Society, Morris, Connecticut.*

Sandy Beach in the early part of the twentieth century. *Collection of the Litchfield Historical Society, Litchfield, Connecticut.*

A 1932 map of the Wild Gardens of Litchfield, today part of White Memorial. *Collection of the Litchfield Historical Society, Litchfield, Connecticut.*

White moved his family to Litchfield in 1863, in the wake of the New York City draft riots. They built their home, Whitehall, near the Bantam River. This area of the river, once known as Love Grove, had been a popular location for students from the law school and female academy in the early 1800s.

Between 1908 and 1913, Alain and May began purchasing land around Bantam Lake, eventually owning 60 percent of the shoreline. Finding it difficult to manage their properties, the Whites established the White Memorial Foundation in honor of their parents in 1913. In addition to land purchases, the Whites gifted in excess of $400,000 to the foundation, a sum that would exceed $5 million today. The Whites' neighbors were not immediately supportive of their land purchases and couldn't surmise why the foundation would let land return to forest. One such neighbor was the Berkshire Ice Company, which rejected offers from the Whites to purchase its property until the complex was destroyed by fire in 1929.

The end result of the Whites' work was the largest wildlife and nature center in Connecticut, one that totaled 3,960 acres. It was built on the founding principles of conservation, recreation, education and research. The Whites, however, believed in practical conservationism and thought their lands should be working forests and, as such, operated sawmills and charcoal works and harvested maple syrup.

They also sought to, in the words of historian Rachel Carley, "make shoreline available for youth camps, simple vacation homes and convalescent retreats." One of the Whites' early purchases was the Wadhams farm on Bantam Lake, which became Sandy Beach, used by thirty thousand people in the summer of 1930. The purchase of the Lakeside Inn along North Shore Road in Bantam allowed May White to fulfill her goal of opening a convalescent home. This became Sheltering Arms, a camp for children from New York City; today it is Camp Hope, which serves a similar purpose. Point Folly, originally a picnic area that served three hundred people a day in the 1930s, opened forty-eight campsites in 1973. The foundation continues to lease land to the owners of one hundred lakeside cottages.

The Whites also contributed land to other causes they deemed important, including the Connecticut State Police, Litchfield's Community Field, Litchfield and Region 6 schools and the Bantam Civic Association. Alain and May donated 5,745 acres to fourteen Connecticut state parks, most in northwestern Connecticut. The foundation supported the Boy Scouts by leasing Camp Boyd, adjacent to Sandy Beach (the cabin burned in the 1970s), and the Girl Scouts through Camp Townshend, located along Alain White Road in Morris (the camp closed in the mid-1970s). Alain White

was concerned about the plight of the wood duck and was involved in the creation of a bird and game sanctuary that raised thousands of ducks and pheasants between 1923 and 1940.

In 1922, the White Memorial Foundation leased 150 acres east of Little Pond to the Litchfield Garden Club for the "creation and maintenance of a wild garden containing trees, shrubs and flowers native to Connecticut and to Litchfield County." (The garden club paid one dollar to lease the land for ten years.) The garden club created trails through this area to allow visitors to access the flora. This became known as the Litchfield Wild Garden. In 1928, the Munroe Bridge was built to offer visitors access to the west side of the Bantam River as it flowed into Little Pond. Today, this is part of the boardwalk trail, one of the highlights of the fifty-four thousand visits made every year to White Memorial. Numerous monuments commemorate the Whites' work; perhaps the most impressive is a carved boulder in the woods near the Plunge Pool.

A similar operation to the Whites' was taking place in Washington. Ehrick Kensett Rossiter was a noted architect, educated at the Gunnery and at Cornell University. While he designed Washington's Gunn Memorial Library and St. John's Church, perhaps his most lasting legacy to the town was the Steep Rock Land Trust.

In 1881, Rossiter returned to Washington to visit Frederick Gunn, founder of the Gunnery. He purchased six acres of land on which he planned to build a summer home. Those plans were put on the back burner, however, when he learned a timber company was going to clear a valley through which Gunn used to hike with his students. Rossiter purchased the one hundred acres, which became the heart of his preserve.

Rossiter purchased additional lands for Steep Rock and worked to promote Washington as a summer resort. He designed summer homes and hotels and secured the services of Washington Roebling, engineer of the Brooklyn Bridge, to build a suspension bridge allowing passengers from the railroad to reach the Rossiter-designed Holiday House. By 1925, Rossiter had deeded his land to a trust and designated nine trustees. The Steep Rock Association has shepherded the growth of the landholdings from Rossiter's 100 acres to today's 2,700.

The examples of the Whites and Rossiter are matched in spirit if not in size by dozens more conservationists who have helped to preserve the county's landscape. Among these are the Morosanis, whose Laurel Ridge

The view of the Clamshell from Steep Rock, 1906. Threats to this view prompted Ehrick Rossiter to preserve the land. *Collection of the Gunn Memorial Library and Museum, Washington, Connecticut.*

Foundation is noted for its daffodils every spring; Edith Morton Chase, daughter of a brass magnate whose home became Topsmead State Forest; and S. Dillon and Mary Livingston Ripley, whose Kilvarock estate became the Livingston Ripley Waterfowl Conservancy.

Franklin Delano Roosevelt signed the legislation establishing the Civilian Conservation Corps on March 31, 1933. Over the next eight years, approximately three million men served in the CCC, providing income for their families ravaged by the Great Depression.

One of the first camps was Camp Cross in West Cornwall, Connecticut. Named for Connecticut governor Wilbur Cross, it opened on June 20, 1933,

To Honor The Men Of
Camp Macedonia
Company 1191
Established 1935

Civilian Conservation Corps
1933-1942
Created By
President Franklin D. Roosevelt
Renewing The Country's Natural Resources
And Challenging The Human Spirit
Of A Nation In Depression

Commemorative marker for the Civilian Conservation Corps' camp at Kent Falls. *Photo by author.*

and was one of the original thirteen camps in the state. Commanded by Thomas C. Hood, the camp housed the 182nd Civilian Conservation Corps, which was trained in fighting forest fires, chopping and sawing wood and identifying trees.

For their first task, the men of the 182nd cleared 45 acres in the Housatonic Meadows State Park, which had been established in 1927. Here they also planted 45,000 red pine trees in 1933 and another 28,500 trees (red and Scotch pine, European larch, hemlock and white spruce) in 1936. The corps also repaired and maintained roads and constructed stone walls in the park. By 1936, the 182nd was working 6,800 acres and had mapped topographic and recreational features and catalogued trees on the property.

A second CCC camp was established in Kent. The men of the camp constructed both Kent Falls and Macedonia Brook State Parks. At Kent Falls, the men built stone walls and constructed the picnic area and trails to the top of the falls. Remarkable retaining walls built by the CCC are still visible along the yellow-blazed trail. At Macedonia, the CCC laid out the "high road" along the base of Cobble Mountain, a popular hiking and cross-country skiing trail.

In exchange for their labor, the men received thirty dollars per month, twenty-five dollars of which had to be sent home to their families. They

were also provided with food, lodging, medical care and education, a desired commodity, as most of the men had only finished eighth grade. Responsible men were paid an extra fifty cents a week to serve as leaders, helping the two army officers stationed at the camp with its administration. The attack on Pearl Harbor eliminated the needs for the camps but not before the CCC allowed millions of men an opportunity to help provide for their families and thousands of acres in Connecticut were transformed.

⁂

Man cannot always protect Litchfield County's environment. Atop any list of the county's ecological treasures would have been Cornwall's Cathedral Pines, at forty-two acres one of the largest stands of white pines and hemlocks (some reaching 120 feet high) east of the Mississippi. In one of the county's first acts of ecological awareness, the Calhoun family purchased the land in 1883 to protect it from logging. The family donated Cathedral Pines to the Nature Conservancy in 1967.

On Monday, July 10, 1989, a powerful family of tornados came out of New York State and ripped apart Cornwall's Mohawk Ski Area, damaging every ski

lift and carrying some of their chairs miles away. Winds in excess of 150 miles per hour blew through Milton and Bantam, destroying homes, churches and stores. Another tornado hit Watertown, and a girl was killed in Black Rock State Park in Thomaston.

The destruction of Cornwall's Cathedral Pines after the July 1989 tornado. Photo by John Murray, *Litchfield Enquirer*. *Collection of the Litchfield Historical Society, Litchfield, Connecticut.*

Sadly, 90 percent of the trees in Cathedral Pines were destroyed. The Nature Conservancy's decision to take a "natural course" by not removing the downed trees sparked debate. While the group issued a press release stating, "Monday's storm was just another link in the continuous chain of events that is responsible for shaping and changing this forest," others believed that the fallen trees posed a fire hazard to the town, pushed for the trails to be restored and urged that new pines be planted. The county's transformation back to a landscape that *Departures* magazine has described as "storybook New England" has not been without controversy.

Perhaps there is no better metaphor for the history of Litchfield County than its ubiquitous stone walls. Constructed from colonial times through the middle of the nineteenth century, they stand as testimony to the intrepid early settlers who cleared the land in the hopes of making a living from the county's soil. In plowing their fields, they utilized these unwanted stones to dam streams, mark roadways and property boundaries and pen in livestock. Yet the explorer is struck to find these vestiges of an earlier time in the county's deepest forests, an indication that this land was once cleared and worked but has since been reclaimed by forests as lifeways in the county changed. Unfortunately, Connecticut (unlike Massachusetts and New Hampshire) has no law that protects its stone walls, and they are slowly falling victim to bulldozers or being quarried for new stonework.

Epilogue

On a thirty-one-acre plot of state-owned land along Above All Road in Warren sits a decaying and unmarked cinder block structure, once part of a cornerstone of American national defense. Beginning in 1957, IBM constructed the Semi-Automatic Ground Environment (SAGE), the largest computer in history. Based at over twenty direction centers that each contained a building one acre in area, these installations were linked by primitive modems, making SAGE a precursor to the Internet.

This massive computer system was constructed during the Cold War to analyze data that poured into it from hundreds of radar installations across the country. The structure in Warren was one such installation, labeled "New Preston Gap-Filler RADAR Annex p-50A/Z-50A." Like the others, the Warren radar facility tracked the skies for incoming Soviet missiles and bombers. This particular site provided low-altitude coverage, thereby assisting larger installations that were constructed in Newark, New Jersey; Montauk, Long Island; the Boston area; and southern Vermont. The Warren facility was unmanned and consisted only of the radar tower (the footings of which are still visible), the building that housed the radar equipment and a generator. It operated from 1957 through 1968.

Its readings were continuously sent via telephone lines to the SAGE direction center near Syracuse, New York, which then fed it via modem to the nationwide system. The "semi-automatic" in the name SAGE references the fact that the system was empowered to launch anti-missile defenses: planes and missiles, including the CIM-10 Bomarc, which had the capacity

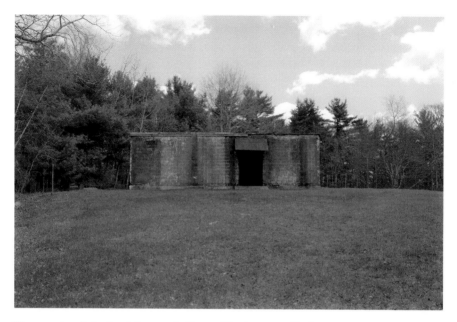

The remains of the Semi-Automatic Ground Environment (SAGE) radar installation in Warren. *Photo by author.*

to carry a nuclear warhead. The entire SAGE system cost about $10 billion in the 1950s, or nearly $70 billion today.

Warren's SAGE radar site highlights a problem in preserving Litchfield County's rich history. The theme of this book has been that the extant cultural landscape provides a window to the past. The organizations that have worked tirelessly over the decades to preserve the Glebe House, Beckley Furnace and Merwinsville Hotel—just to name a few—have ensured that the important roles these sites played in the county's history will be remembered.

But what of the SAGE radar installation? It has no monuments or markers. Litchfield County has had a long tradition of recognizing both its important contributions to American history (the monuments at the sites of Joseph Bellamy's church and John Brown's birthplace, for example) and events of more local importance (such as the water monument on the Litchfield Green). While we recognize the significance of these older sites, we tend not to see more modern structures as part of history. However, for future generations of Litchfield County residents to be able to appreciate the full scope of the region's past, we must continue the process of commemorating this past. Otherwise, we risk a history that is buried rather than hidden.

Works Consulted

Annual Report of the State Board of Charities of the State of Connecticut. Hartford: State of Connecticut, 1920.

Bailey, Bess, and Merrill Bailey. *The Formative Years: Torrington, 1737–1852.* Torrington, CT: Torrington Historical Society, 1975.

Baldwin, Alice Mary. *The Clergy in Connecticut in Revolutionary Days.* New Haven: Connecticut Tercentenary Commission, 1936.

Barber, John W. *Connecticut Historical Collections.* New Haven, CT: John W. Barber, 1836.

Black, George. *The Trout Pool Paradox.* Boston: Houghton Mifflin, 2004.

Boswell, George C. *The Litchfield Book of Days.* Litchfield, CT: Alex. B. Shumway, 1899.

Brickley, Lynne. "Litchfield's Fortunes Hitched to the Stagecoach." *Hog River Journal* 6, no. 2 (Spring 2008).

———. "Tasting the Sweets of Liberty." Unpublished lecture, 2010.

Capen, Edward Warren. *The Historical Development of the Poor Law of Connecticut.* New York: Columbia University Press, 1905.

Carley, Rachel. *Litchfield: The Making of a New England Town.* Litchfield, CT: Litchfield Historical Society, 2011.

Chipman, Samuel. *Report of an Examination of Poor-Houses, Jails, in the State of New-York, and in the Counties of Berkshire, Massachusetts; Litchfield, Connecticut; and Bennington, Vermont.* Albany: New York State Temperance Society, 1836.

Cudworth, Keith. *The White Memorial Foundation: The First 100 Years.* Litchfield, CT: White Memorial Foundation, 2012.

deCourcey, Robert, and Helen Wersebe. *Seventy-Five Years of Steep Rock: A Celebration*. Washington, CT: Steep Rock Association, 2000.

DeForest, John W. *History of the Indians of Connecticut from the Earliest Period to 1850*. Hartford, CT: Wm. Jas. Hamersley, 1853.

DeLuca, Richard. *Post Roads and Iron Horses*. Middletown, CT: Wesleyan University Press, 2011.

Deming, Dorothy. *Settlement of Litchfield County*. New Haven: Connecticut Tercentenary Commission, 1933.

Destler, Chester M. *Connecticut: The Provisions State*. Chester, CT: Pequot Press, 1973.

DeVito, Michael C. *Connecticut's Old Timbered Crossings*. N.p.: DeVito Enterprises, 1964.

Domonell, Bill. "The Statue of King George III." *My Country* 24, no. 2 (Spring 1990).

East, Robert A. *Connecticut's Loyalists*. Chester, CT: Pequot Press, 1974.

Fales, Edward, Jr., ed. *Arsenal of the Revolution: The First History of the "Fourteenth Colony."* Lakeville, CT: Lakeville Journal and the News, 1976.

Frost, William. *Connecticut Education in the Revolutionary Era*. Chester, CT: Pequot Press, 1974.

Goodenough, Arthur. *The Clergy of Litchfield County*. Winchester, CT: Litchfield University Club, 1909.

Gordon, Robert, and Michael Raber. *Industrial Heritage of Northwest Connecticut: A Guide to History and Archaeology*. New Haven: Connecticut Academy of Arts and Sciences, 2000.

Grant, Ellsworth S. *The Miracle of Connecticut*. Hartford: Connecticut Historical Society, 1992.

———. *Yankee Dreamer and Doers: The Story of Connecticut Manufacturing*. Guilford, CT: Pequot Press, 1974.

Grimes, William. *Life of William Grimes, the Runaway Slave*. New York: Oxford University Press, 2008.

Havemeyer, Ann, and Robert Dance. *Picturing Norfolk: 1758–1958*. Norfolk, CT: Norfolk Historical Society, 2008.

Highways and Byways of Connecticut. Hartford, CT: G. Fox & Co., 1947.

Hill, Joseph Adna, Lewis Merian and Emanuel Alexandrovich Goldenweiser. *Paupers in Almshouses 1910*. Washington, D.C.: United States Bureau of the Census, 1910.

History of Litchfield County, Connecticut, with Illustrations and Biographical Sketches of Its Prominent Men and Pioneers. Philadelphia: J.W. Lewis & Company, 1881.

Hollister, G.H. *The History of Connecticut from the First Settlement of the Colony to Present Constitution*. 2 vols. New Haven, CT: Durrie and Peck, 1855.

Key, _____. "Pulling Down the Statue of George III." "Research—King George III (1776) File." Litchfield Historical Society.

Kilbourn, Dwight. *The Bench and Bar of Litchfield County, Connecticut, 1709–1909*. Litchfield, CT: privately published, 1909.

Kilbourne, Payne Kenyon. *Sketches and Chronicles of the Town of Litchfield, Connecticut*. Hartford, CT: Case, Lockwood & Company, 1859.

Kirby, Ed. *Echoes of Iron in Connecticut's Northwest Corner*. Sharon, CT: Sharon Historical Society, 1998.

Klebaner, Benjamin J. "Pauper Auctions: The 'New England Method' of Public Poor Relief." *Historical Collections of the Essex Institute* 91, no. 3 (1955).

Leone, Julie Frey. "The Peace Movement in Litchfield." *Connecticut Explored* 9, no. 2 (Spring 2011).

Lord, Robert F. *Country Depots in the Connecticut Hills*. N.p.: Highland Hardware Co., 1996.

Loskiel, George Henry. *History of the Moravian Mission among the North American Indians*. London: Brethren's Society, 1794.

Lyman, Susan Elizabeth. "The Search for the Missing King." *American Heritage* (August 1958).

MacDougall, William L. *American Revolutionary: A Biography of General Alexander McDougall*. Westport, CT: Greenwood Press, 1977.

Mangan, Greg. "Connecticut Poor Law Aimed to Care for the Needy." Connecticuthistory.org. February 13, 2014.

Mars, James. *Life of James Mars: A Slave Bought and Sold in Connecticut. Written by Himself*. Hartford, CT: Case, Lockwood & Company, 1864.

Martin, Joseph Plumb. *Private Yankee Doodle: A Narrative of Some of the Adventures, Dangers and Sufferings of a Revolutionary Soldier*. Edited by George F. Scheer. New York: Acorn Press, 1979.

McKenna, Marian C. *Tapping Reeve and the Litchfield Law School*. New York: Oceana Publications, 1986.

Mitchell, Isabel. *Roads and Road Making in Colonial Connecticut*. New Haven: Connecticut Tercentenary Commission, 1933.

Mitchell, Mary Hewitt. *The Great Awakening and Other Revivals of the Religious Life in Connecticut*. New Haven: Connecticut Tercentenary Commission, 1934.

Munich, Austin Francis. *The Beginnings of Roman Catholicism in Connecticut*. New Haven: Connecticut Tercentenary Commission, 1935.

Nichols, Marilyn. "Old Grist Mills Cease." Unpublished lecture, Litchfield Historical Society.

Ogden, F.C. "The Story of King George's Statue." *New Canaan Historical Society Annual* (June 1955).

Orcutt, Samuel. *History of the Indians of the Housatonic and Naugatuck.* Hartford, CT: Case, Lockwood and Brainard, 1882.

———. *History of the Towns of New Milford and Bridgewater, Connecticut, 1703–1882.* Hartford, CT: Case, Lockwood and Brainard, 1882.

———. *History of Torrington, Connecticut.* Albany, NY: J. Munsell, 1878.

Philips, David E. *Legendary Connecticut: Traditional Tales from the Nutmeg State.* Hartford, CT: Spoonwood Press, 1984.

Rhea, Gordon. *Cold Harbor.* Baton Rouge: Louisiana State University Press, 2007.

Richards, Josephine Ellis, ed. *Honor Roll of the Litchfield County Revolutionary Soldiers.* Litchfield, CT: Mary Floyd Tallmadge Chapter, Daughters of the American Revolution, 1912.

Rome, Adam Ward. *Connecticut's Cannon: The Salisbury Furnace in the American Revolution.* Hartford: American Revolution Bicentennial Commission of Connecticut, 1977.

Rossiter, Ehrick K. *Washington's Journey Through Litchfield County, September 18, 1780 to September 25th, 1780.* Litchfield, CT: Litchfield County University Club, 1930.

"SAGE New Preston." Coldwar-ct. N.p., n.d. Web. June 27, 2014.

Schlachter, Karl E. *Early Connecticut Railroads, 1830–1908.* N.p., 2008.

Sedgwick, Charles F. *General History of the Town of Sharon from Its First Settlement.* Amenia, NY: Charles Walsh, 1877.

Seventeenth Annual Report of the State Board of Health of the State of Connecticut. Hartford: State of Connecticut, 1895.

Seymour, Origen Storrs. *The Beginnings of the Episcopal Church in Connecticut.* New Haven: Connecticut Tercentenary Commission, 1934.

"Soldiers' Monument and Memorial Park." Soldiers' Monument and Memorial Park. N.p., n.d. Web. June 27, 2014.

Stilgoe, John. *Outside Lies Magic.* New York: Walker and Company, 2009.

Strong, Barbara Nolen. *The Morris Academy: Pioneer in Coeducation.* Morris, CT: Morris Bicentennial Committee, 1976.

Studley, G.L. *Connecticut: The Industrial Incubator.* Hartford, CT: American Society of Mechanical Engineers, 1982.

Thorson, Robert. *Stone by Stone.* New York: Walker and Company, 2004.

"The Town Farm: A Victorian-Era Solution to Poverty." Forgotten New England. forgottennewengland.com/tag/poor-farm. October 11, 2011. (Accessed February 13, 2014.)

Turner, Gregg M., and Melancthon W. Jacobus. *Connecticut Railroads: An Illustrated History.* Hartford: Connecticut Historical Society, 1986.

Two Centuries of New Milford, Connecticut. New York: Grafton Press, 1907.

Vaill, Theodore. *History of the Second Connecticut Volunteer Heavy Artillery*. Winsted, CT: Winsted Printing Company, 1868.

Vanderpoel, Emily Noyes. *The Chronicles of a Pioneer School*. Cambridge, MA: University Press, 1903.

Volandes, Stellene. "Serenity in Litchfield County, CT." *Departures* (March/April 2009).

Walsh, James P. *Connecticut Industry and the Revolution*. Hartford: American Revolution Bicentennial Commission of Connecticut, 1978.

White, Alain C. *The History of the Town of Litchfield, Connecticut, 1720–1920*. Litchfield, CT: Litchfield Historical Society, 1920.

White, David O. *Connecticut's Black Soldiers, 1775–1783*. Chester, CT: Pequot Press, 1973.

White, Ralph. *Images of America: Litchfield*. Charleston, SC: Arcadia Publishing, 2011.

Winslow, Richard. *Major General John Sedgwick: The Story of a Union Corps Commander*. Novato, CA: Presidio Press, 1982.

Wood, Frederic J. *The Turnpikes of New England and the Evolution of the Same Through England, Virginia, and Maryland*. Boston: Marshall Jones Company, 1919.

Woodruff, George C. *History of the Town of Litchfield, Connecticut*. Litchfield, CT: C. Adams, 1845.

About the Author

Peter C. Vermilyea teaches history at Housatonic Valley Regional High School in Falls Village, Connecticut, and at Western Connecticut State University. A graduate of Gettysburg College, he is the director of the student scholarship program at his alma mater's Civil War Institute. Vermilyea is the author or editor of three books and more than a dozen articles, mostly on Civil War history, and maintains the Hidden in Plain Sight blog (www.hiddeninplainsightblog.com). He lives in Litchfield, Connecticut, with his wife and two sons.